UNTITLED

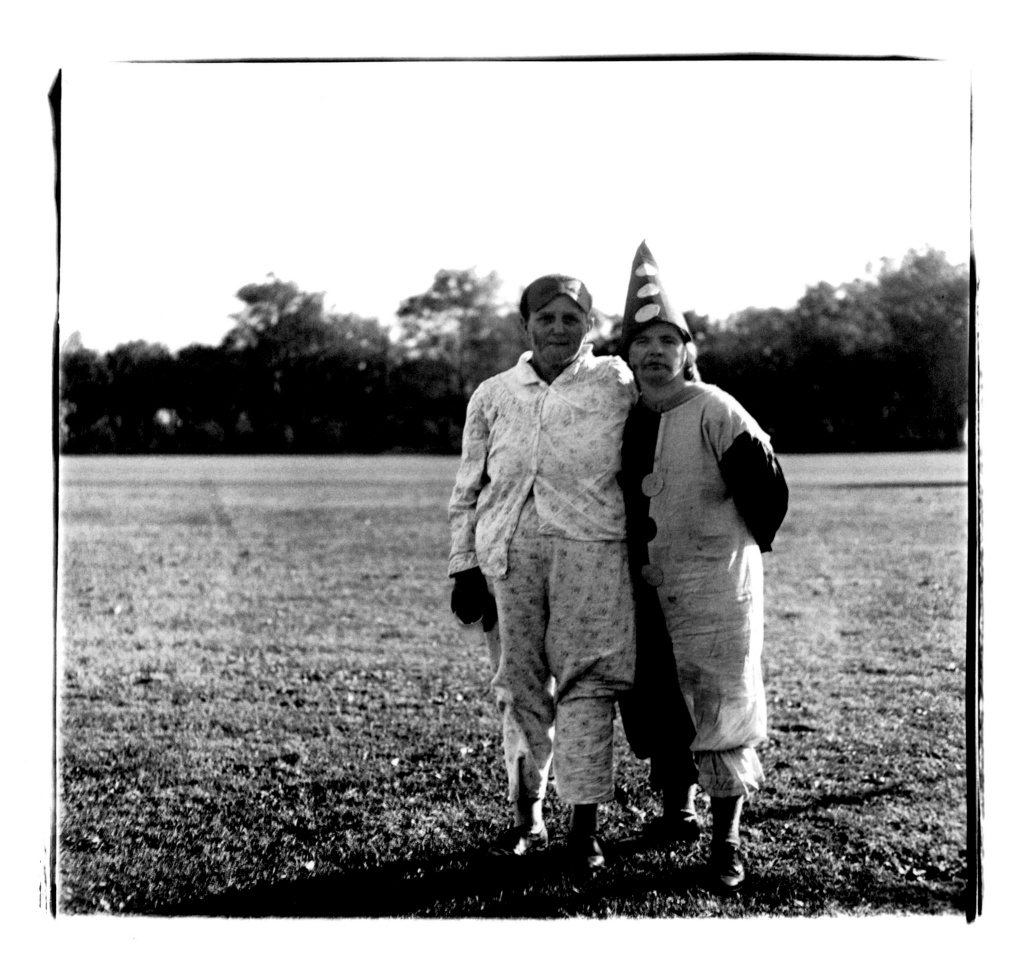

DIANE ARBUS

UNTITLED

APERTURE

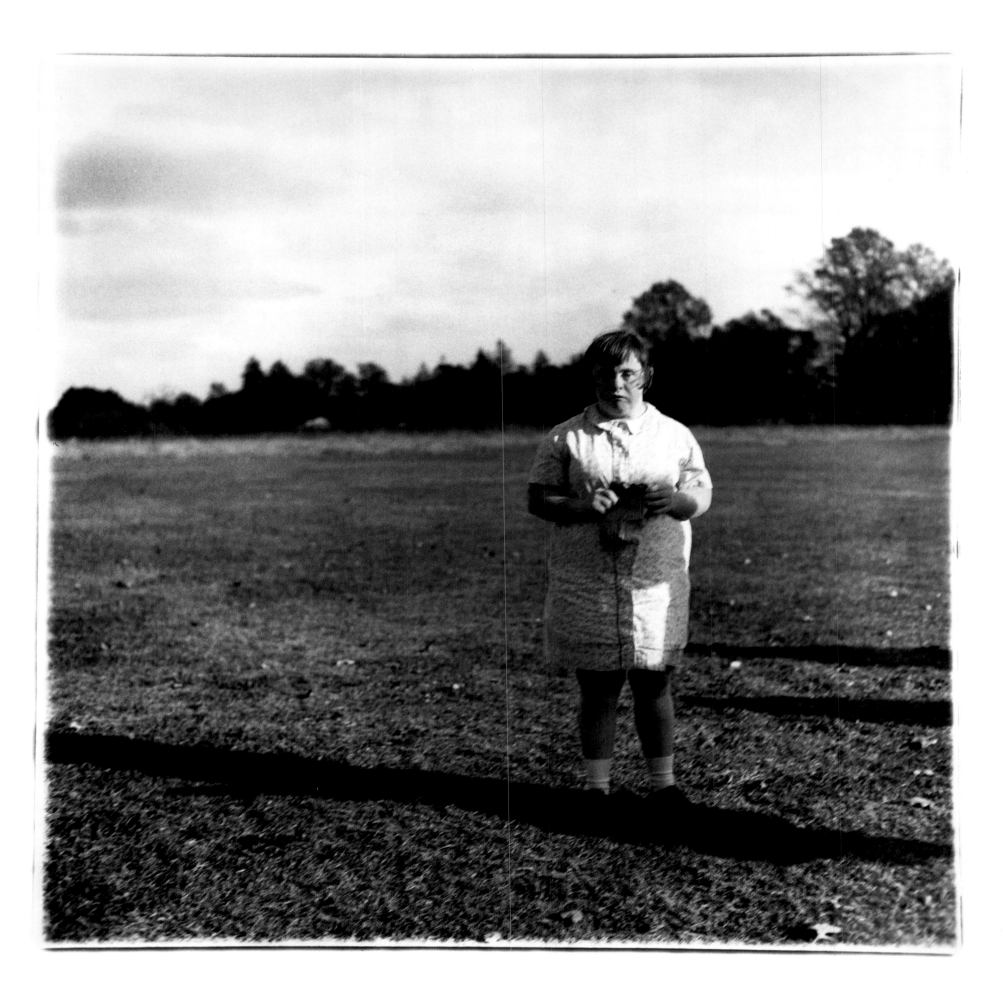

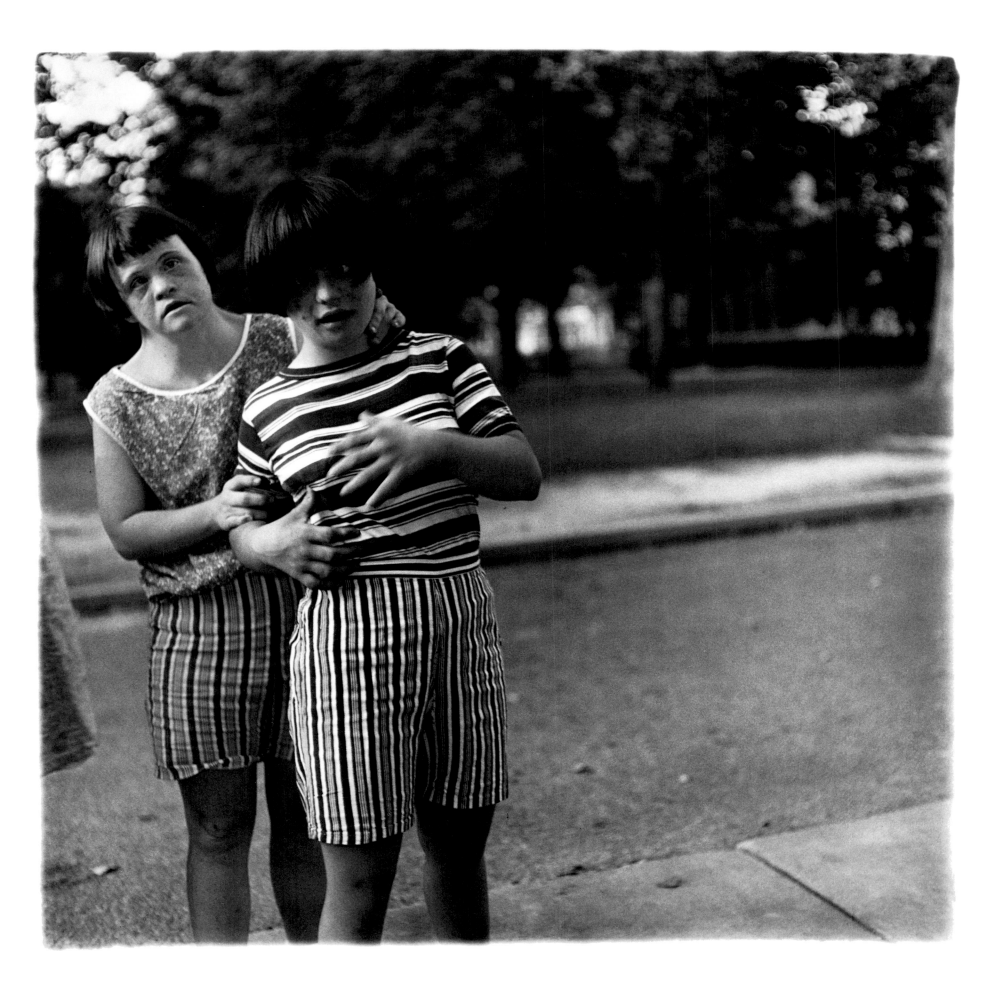

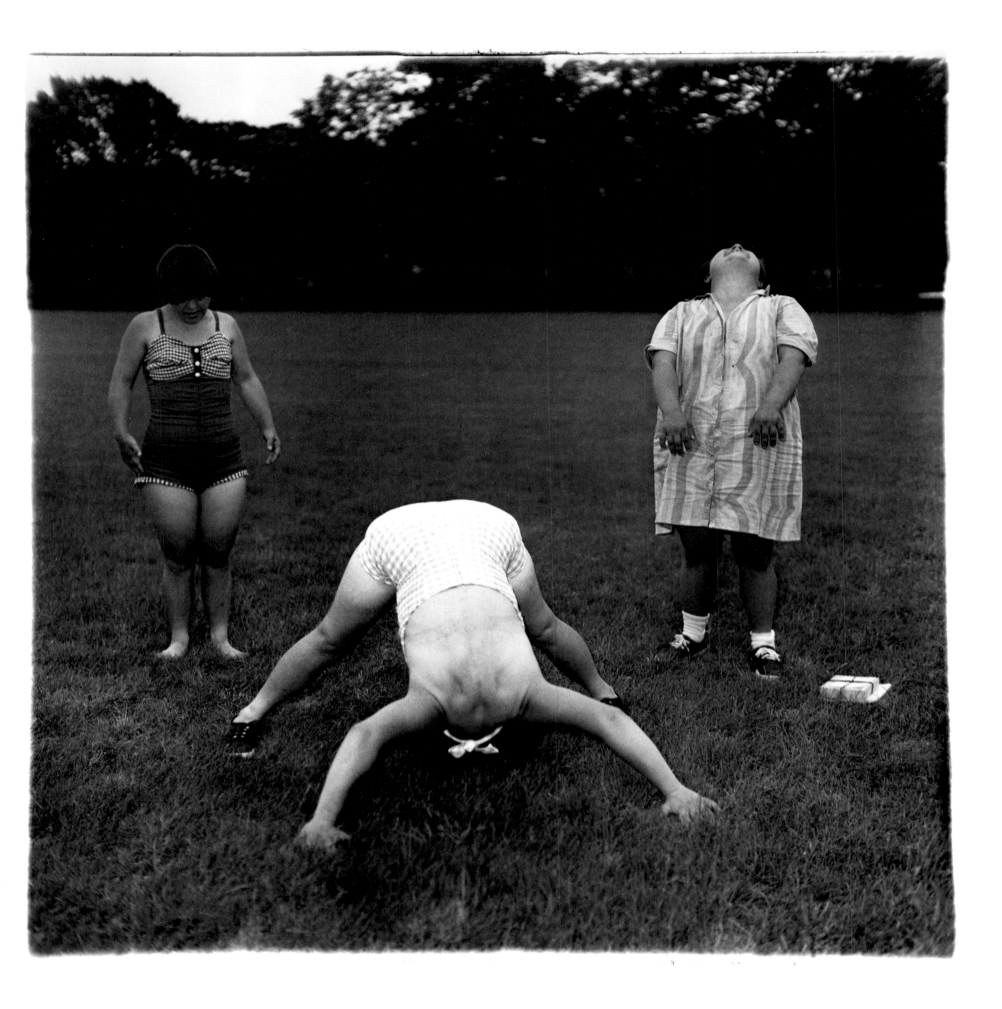

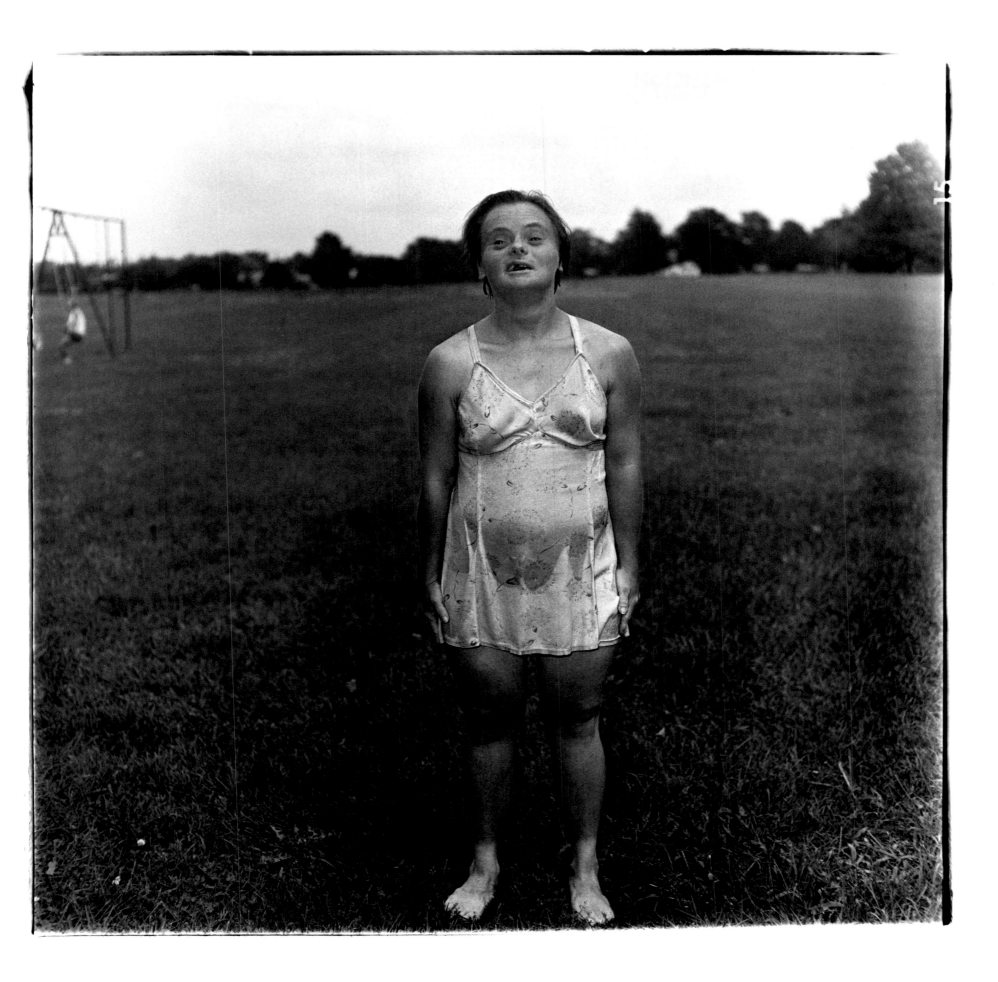

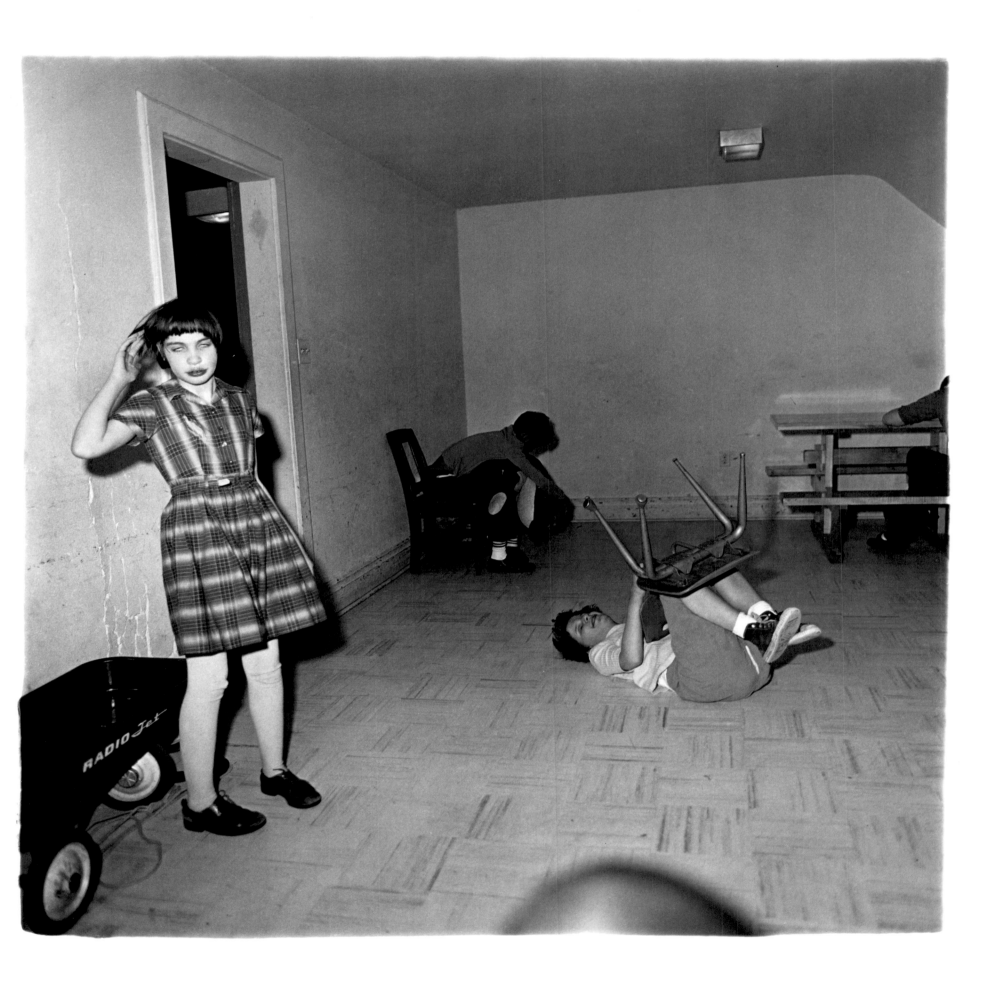

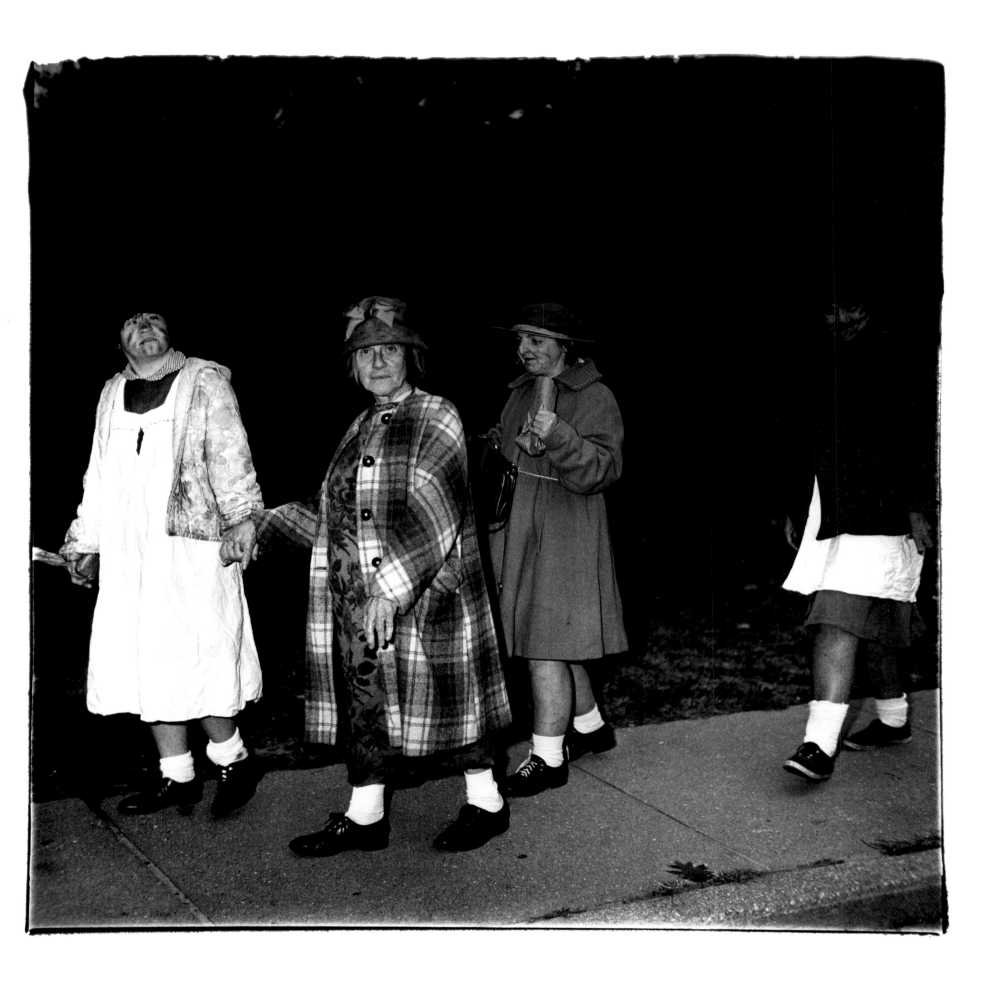

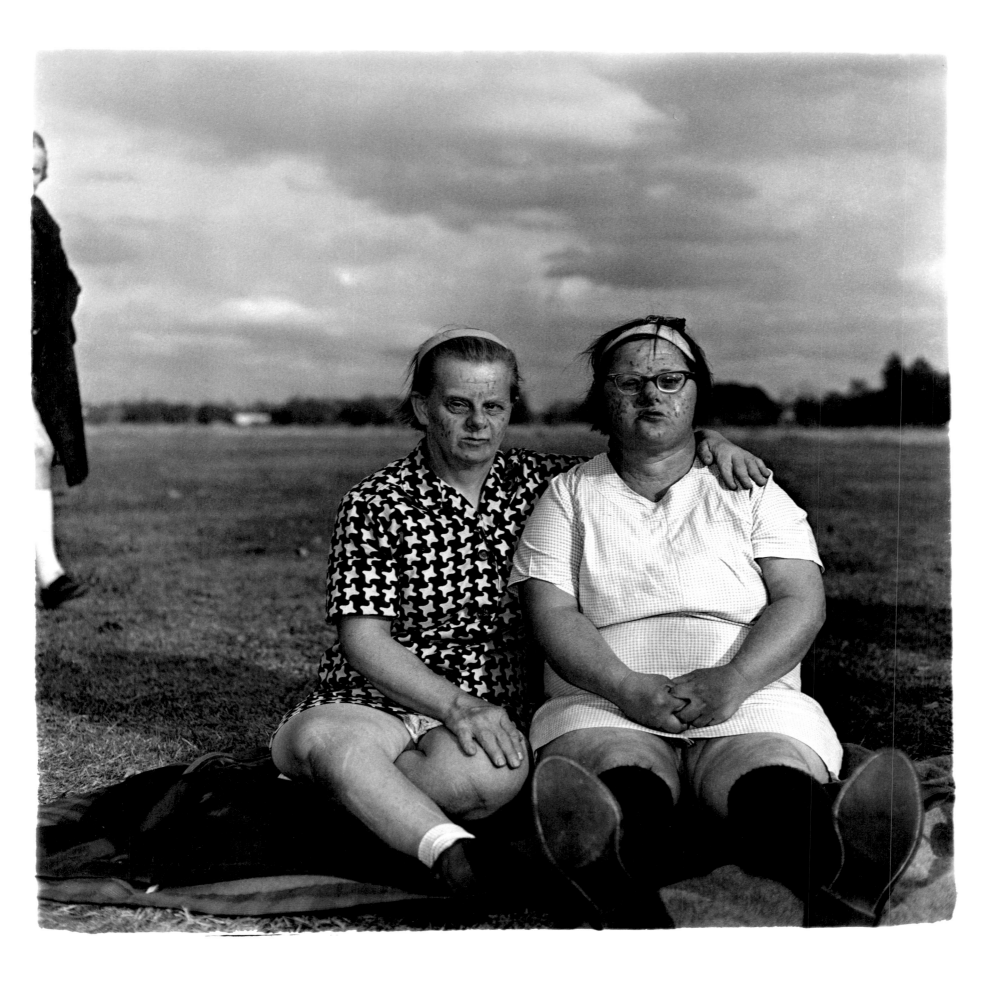

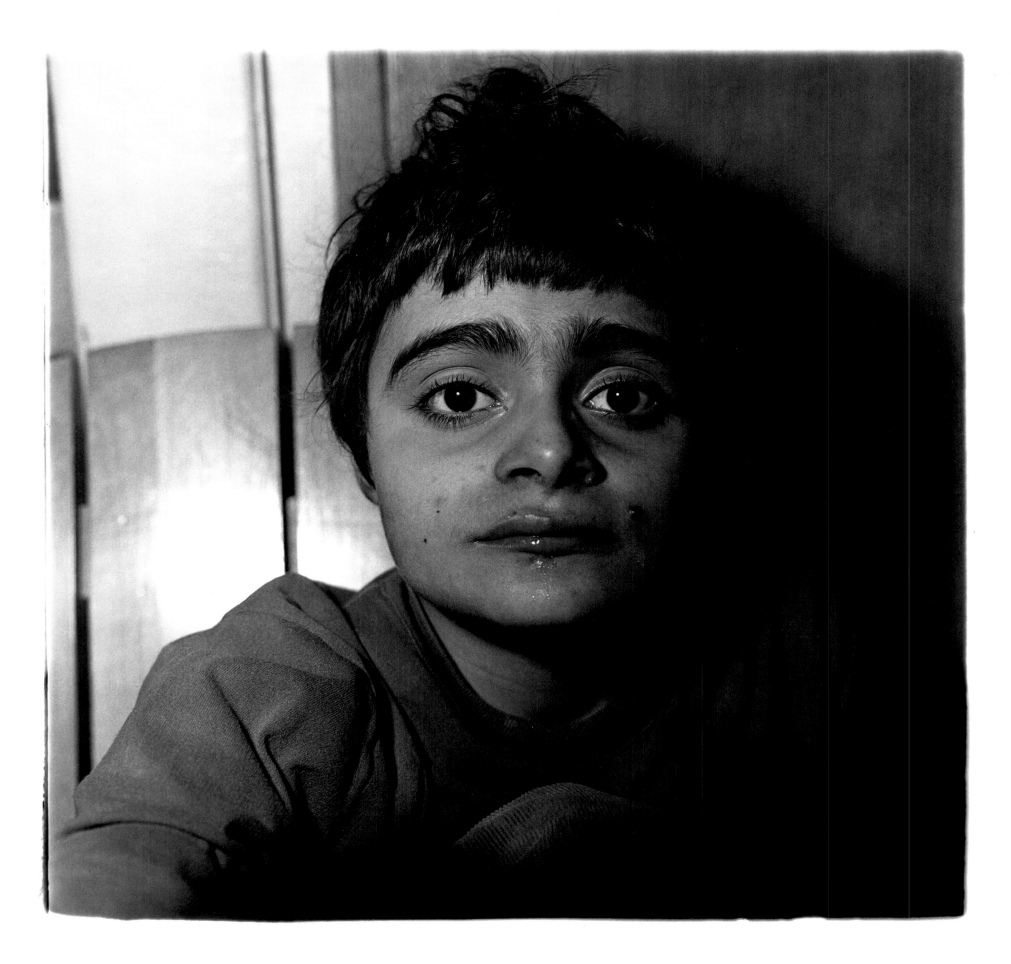

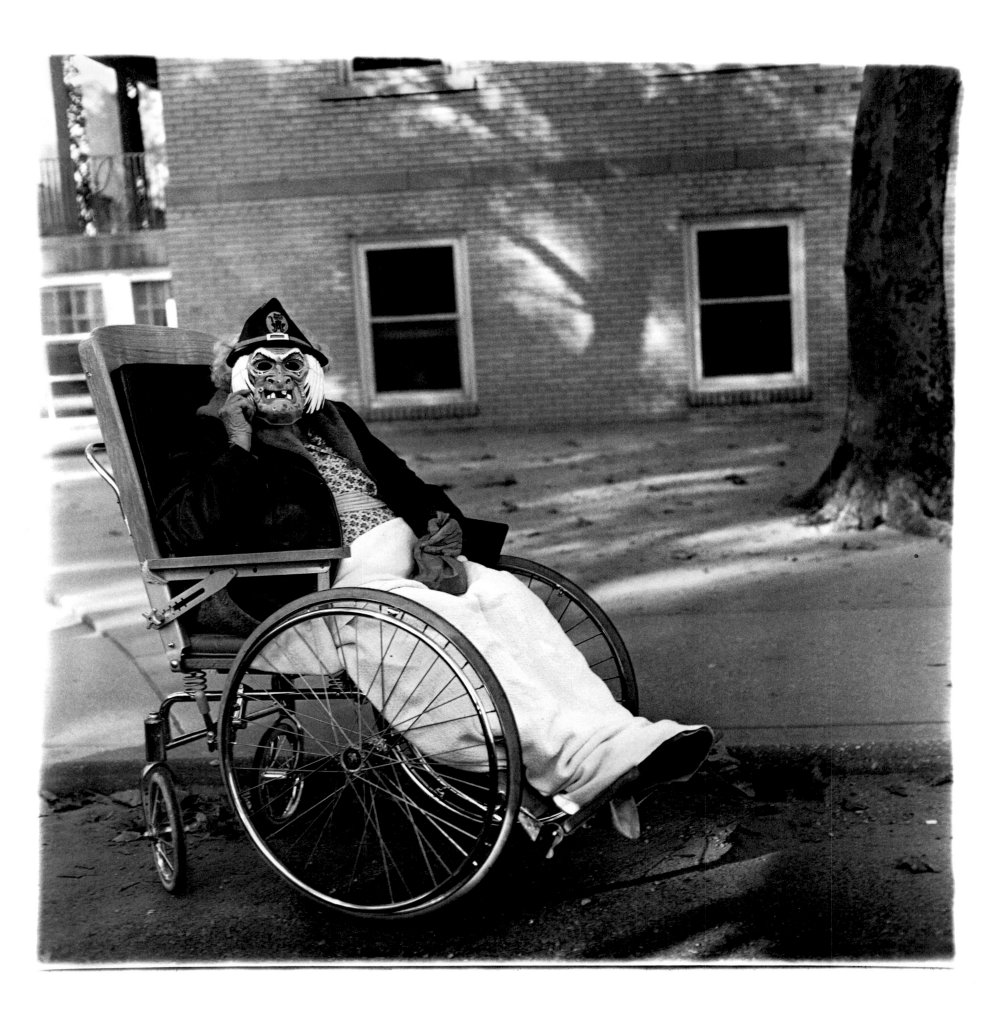

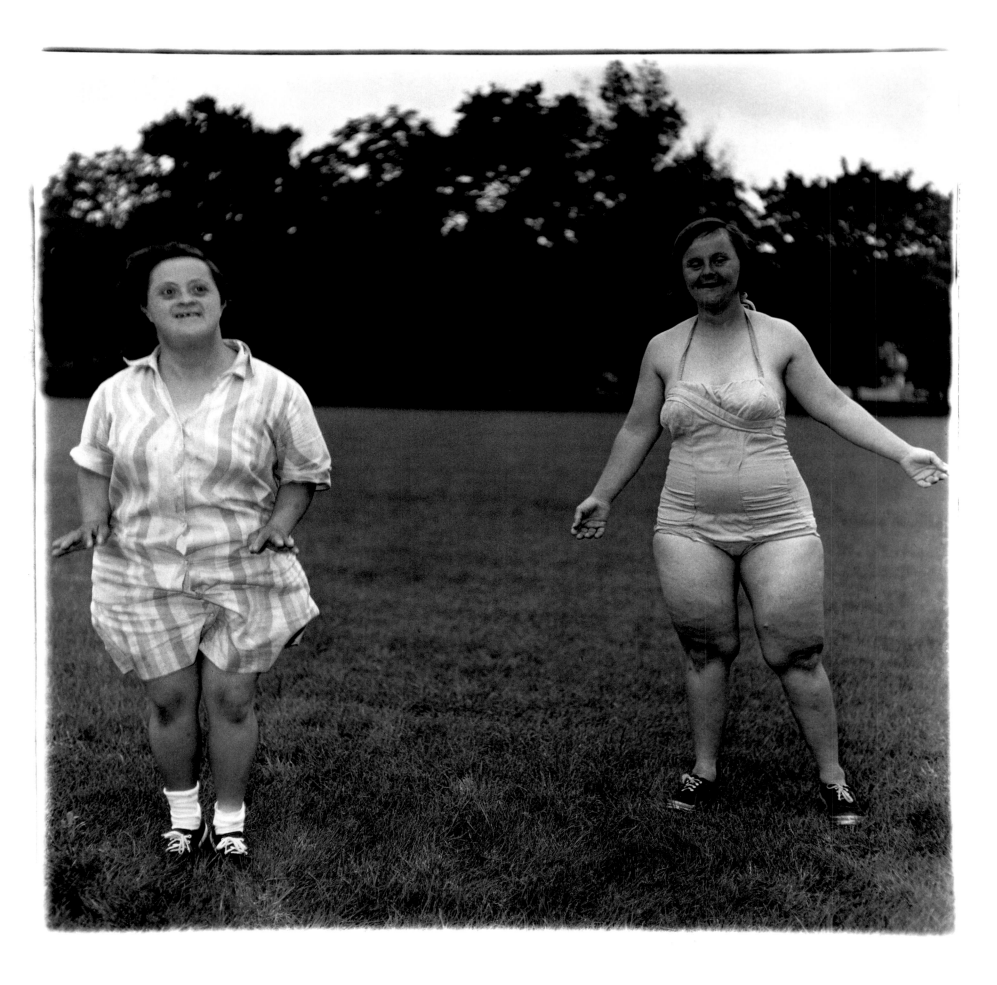

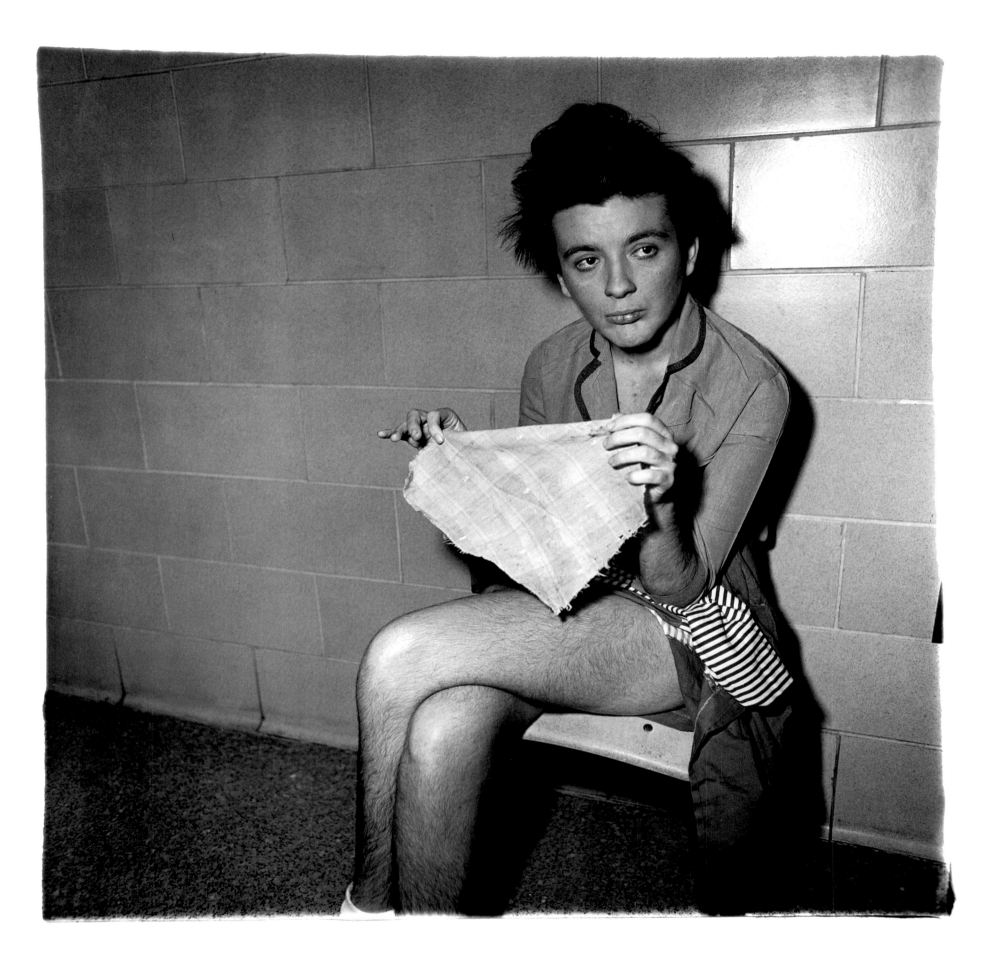

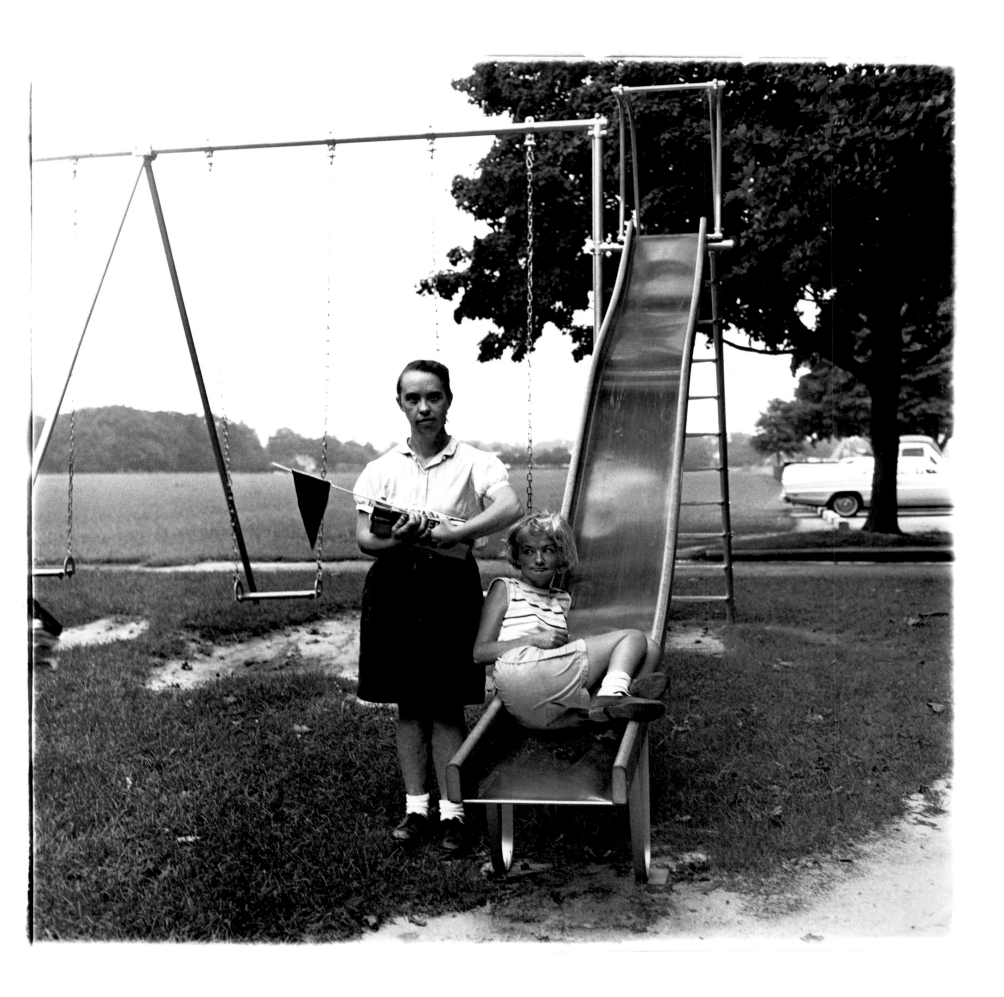

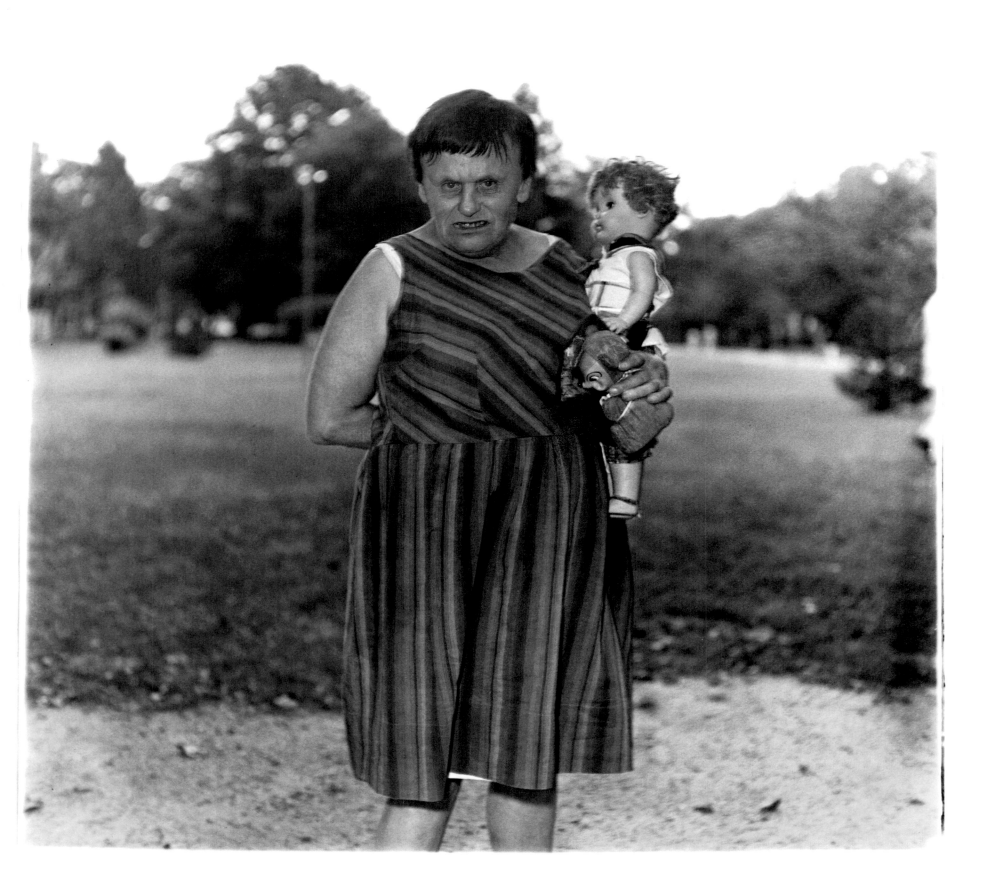

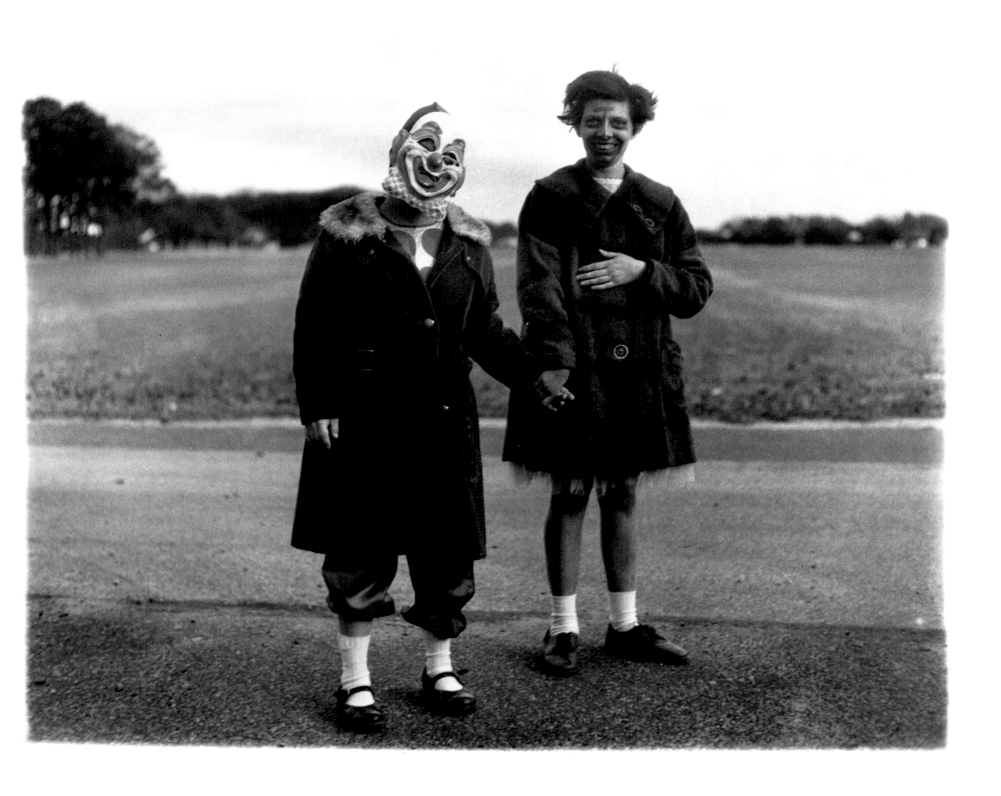

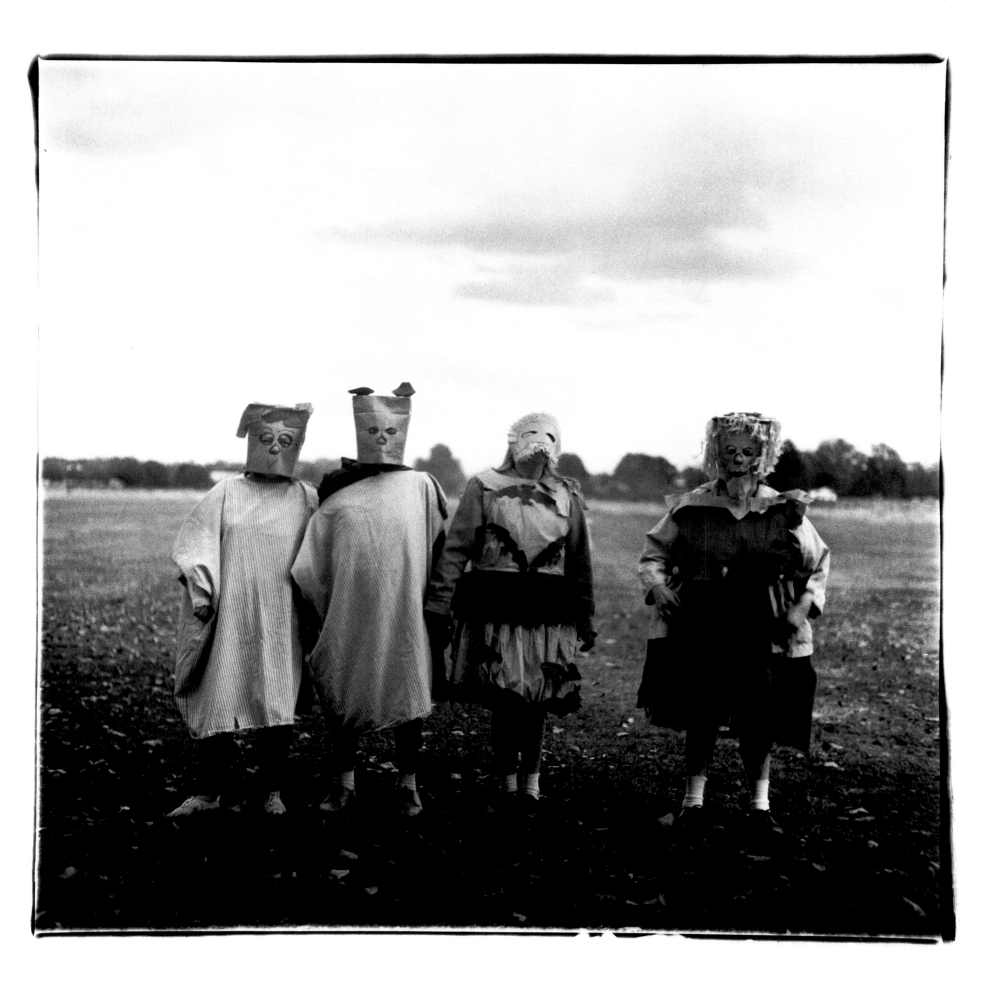

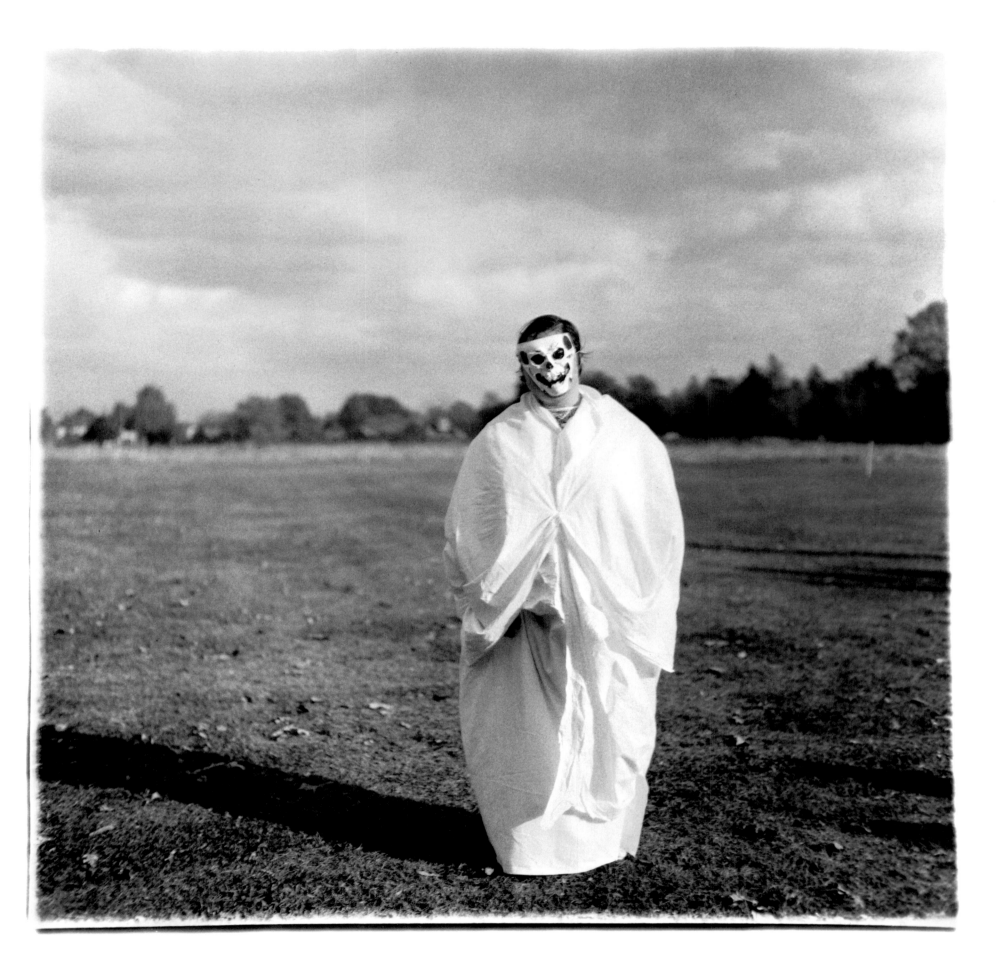

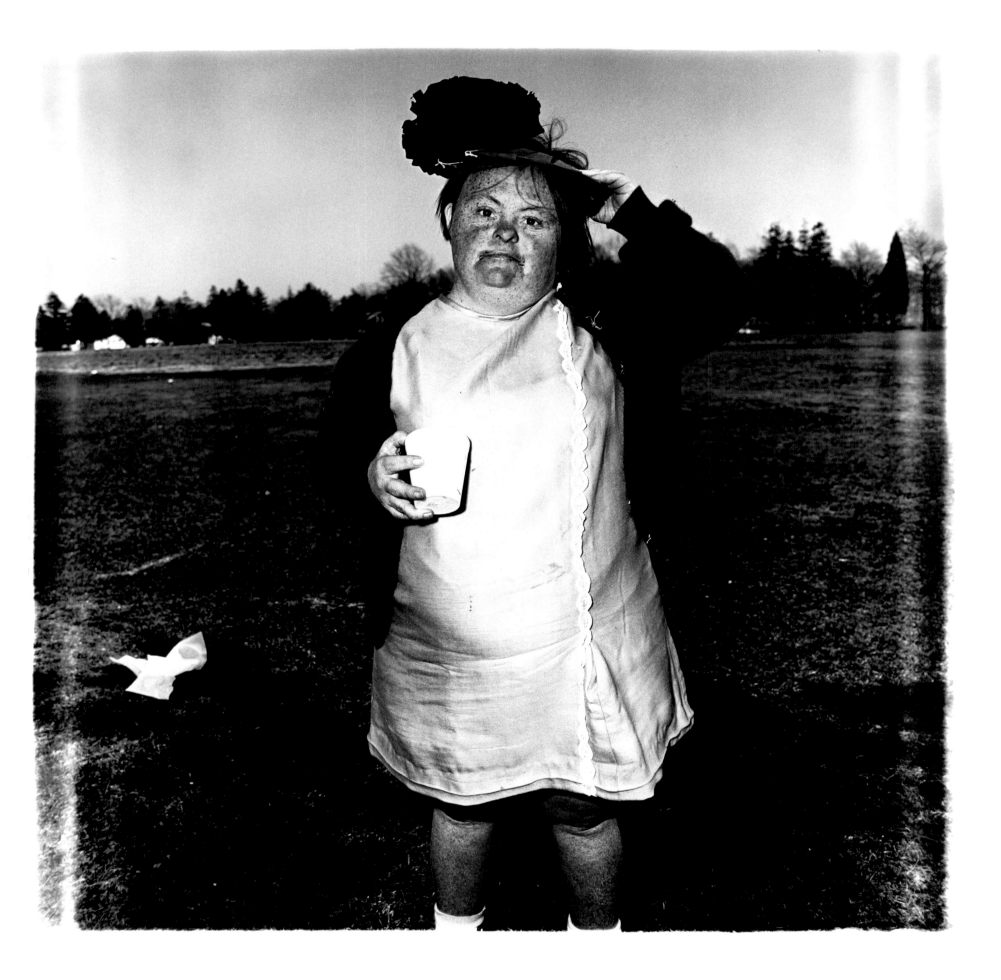

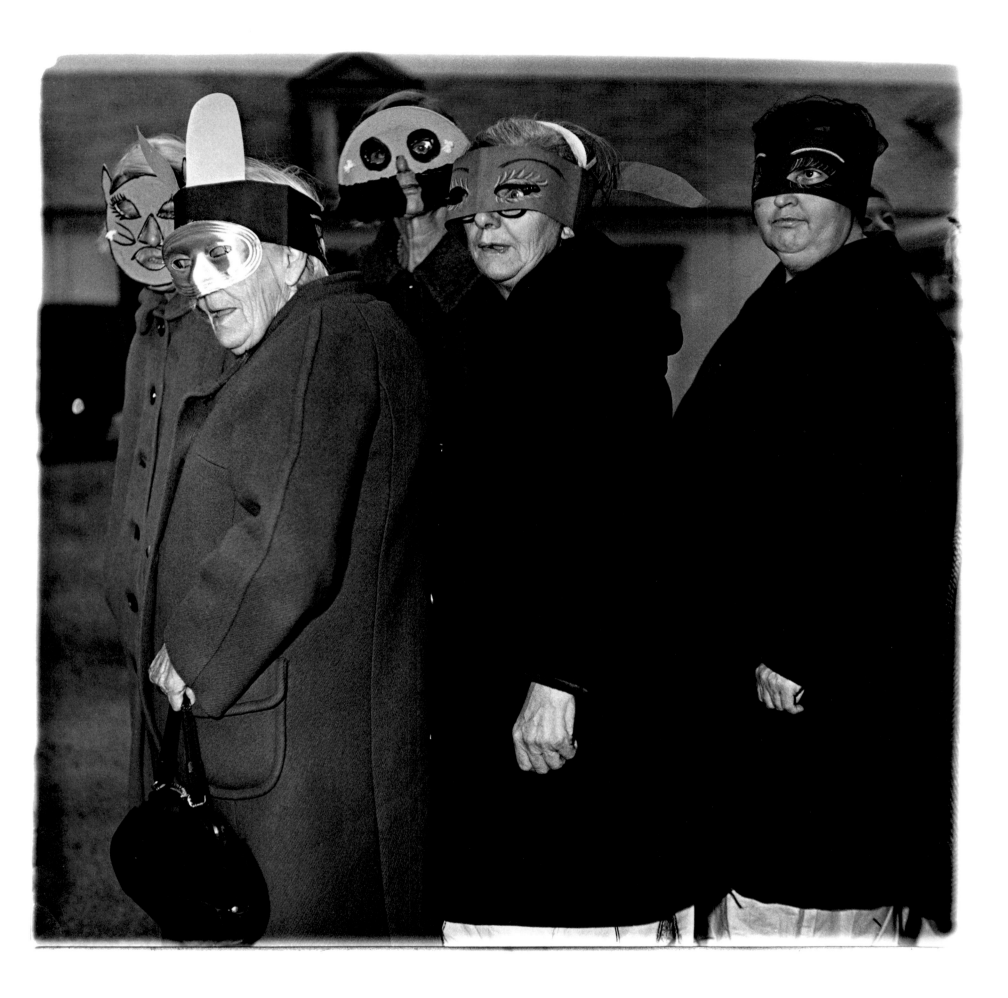

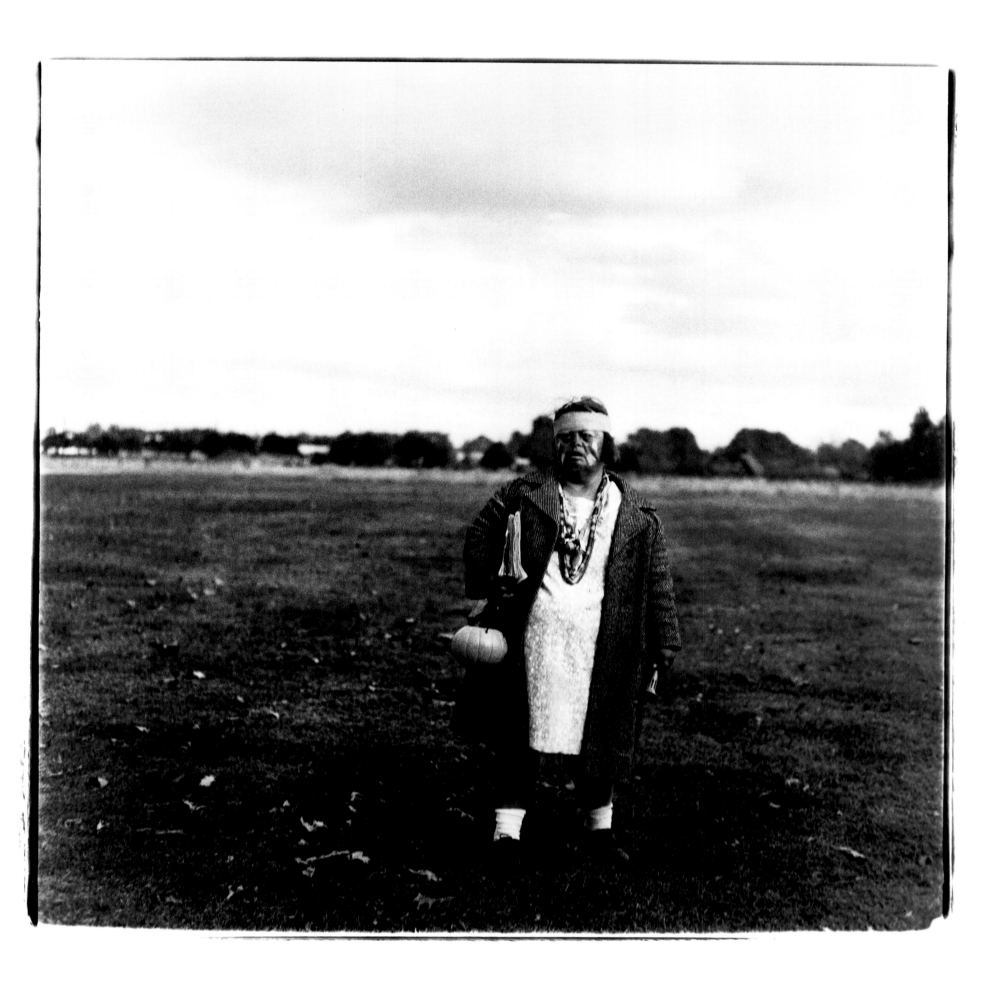

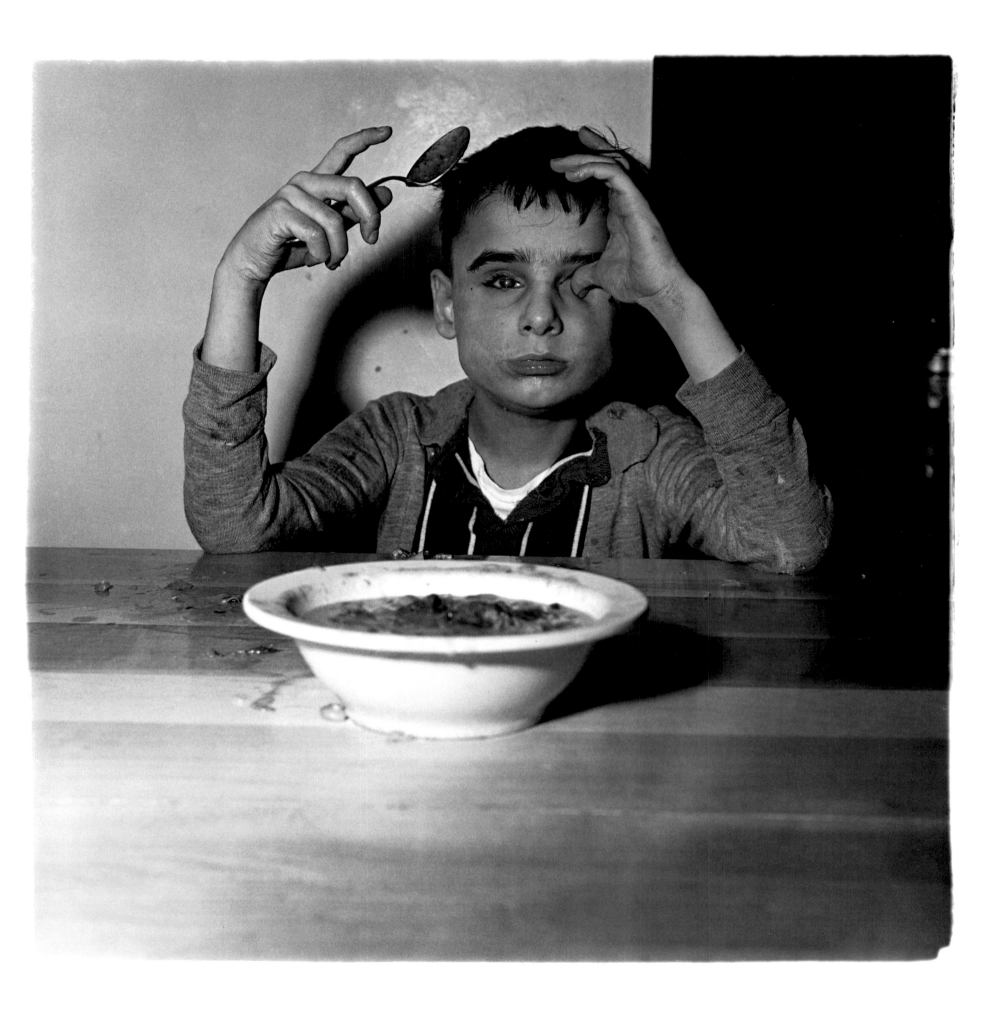

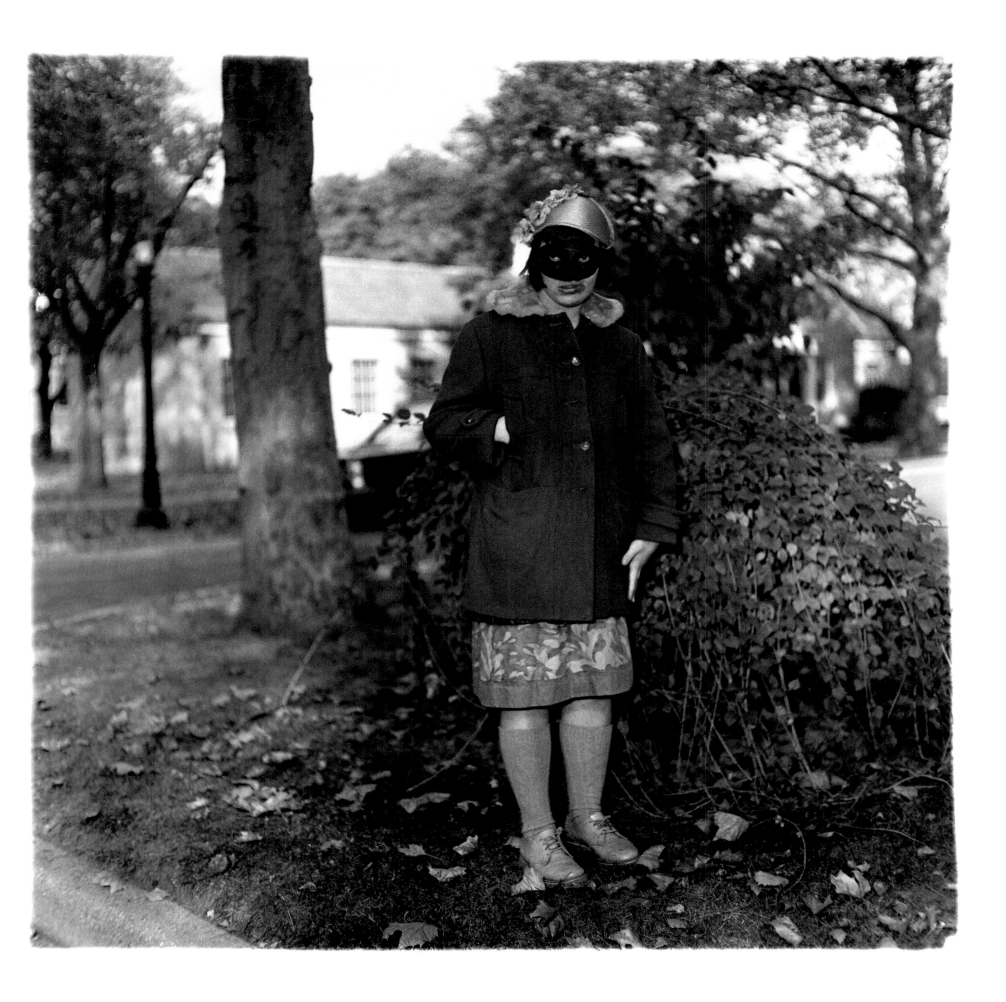

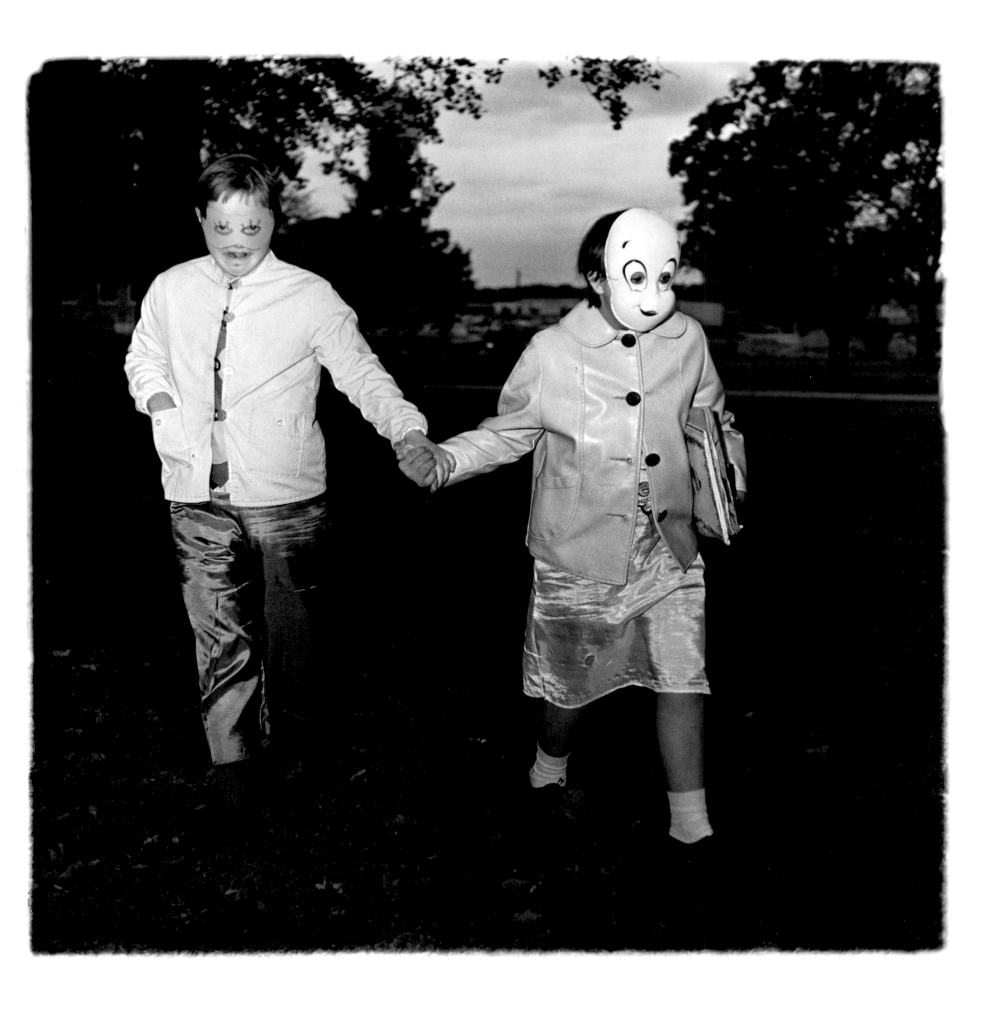

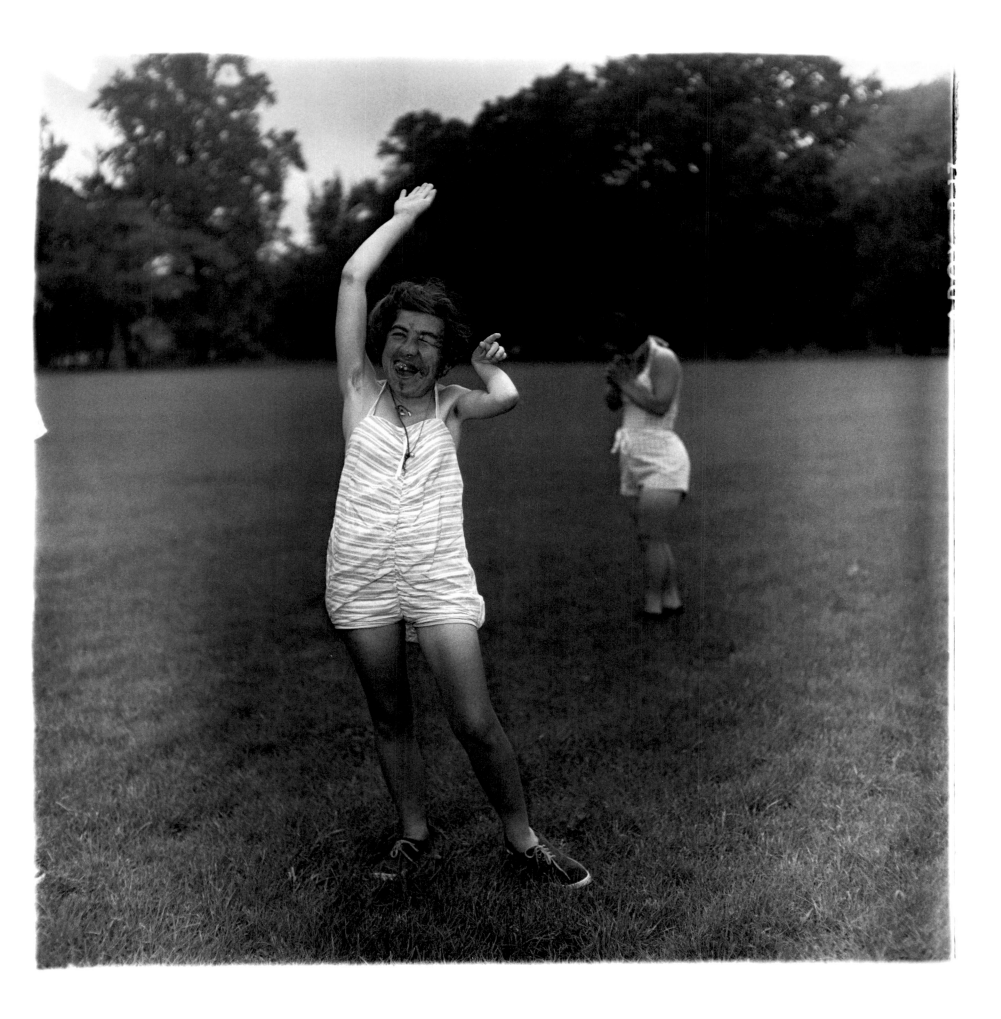

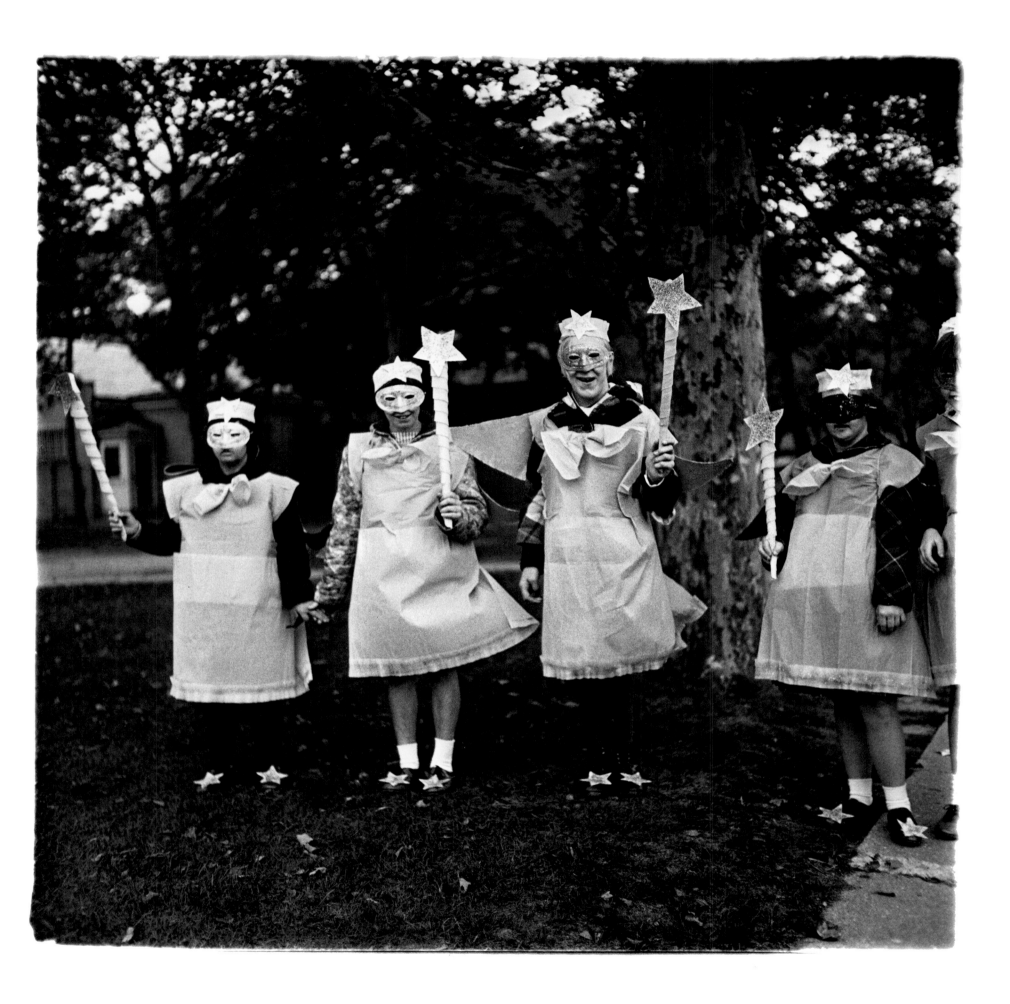

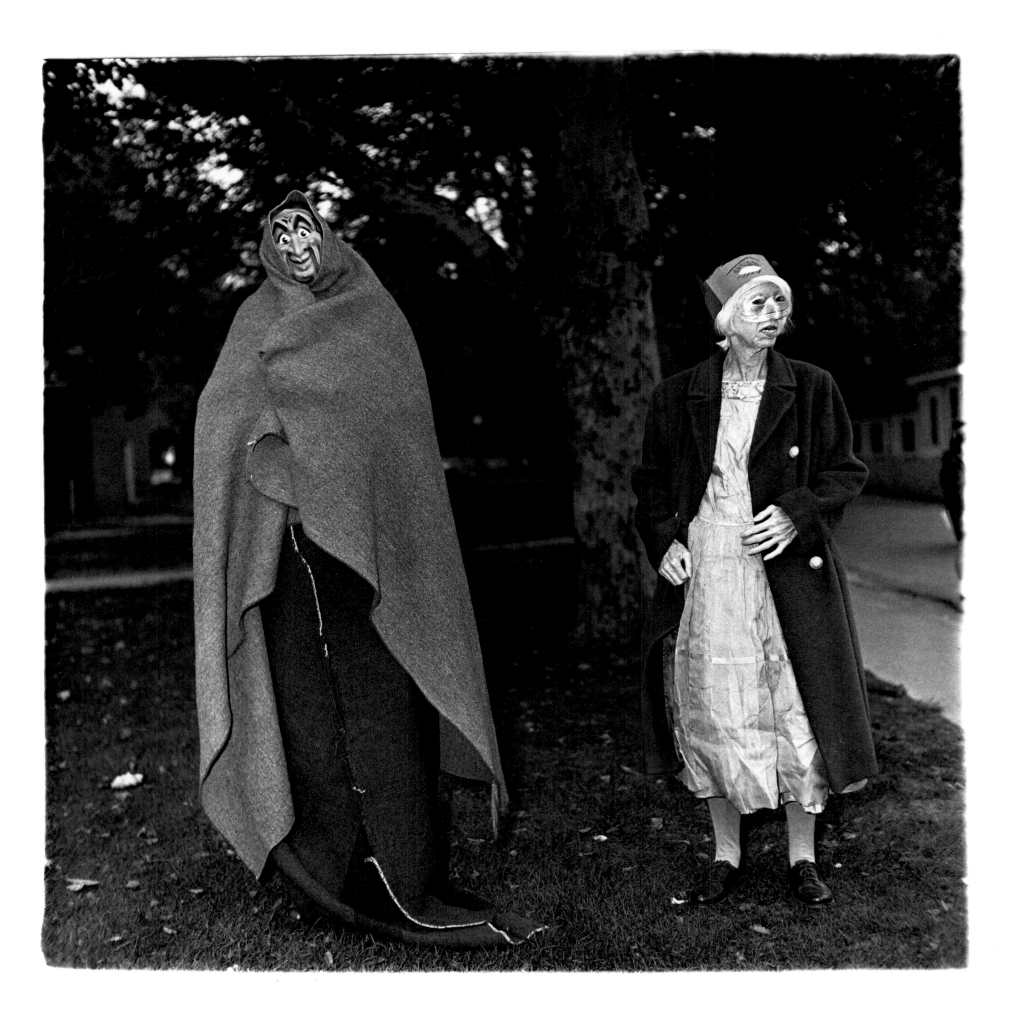

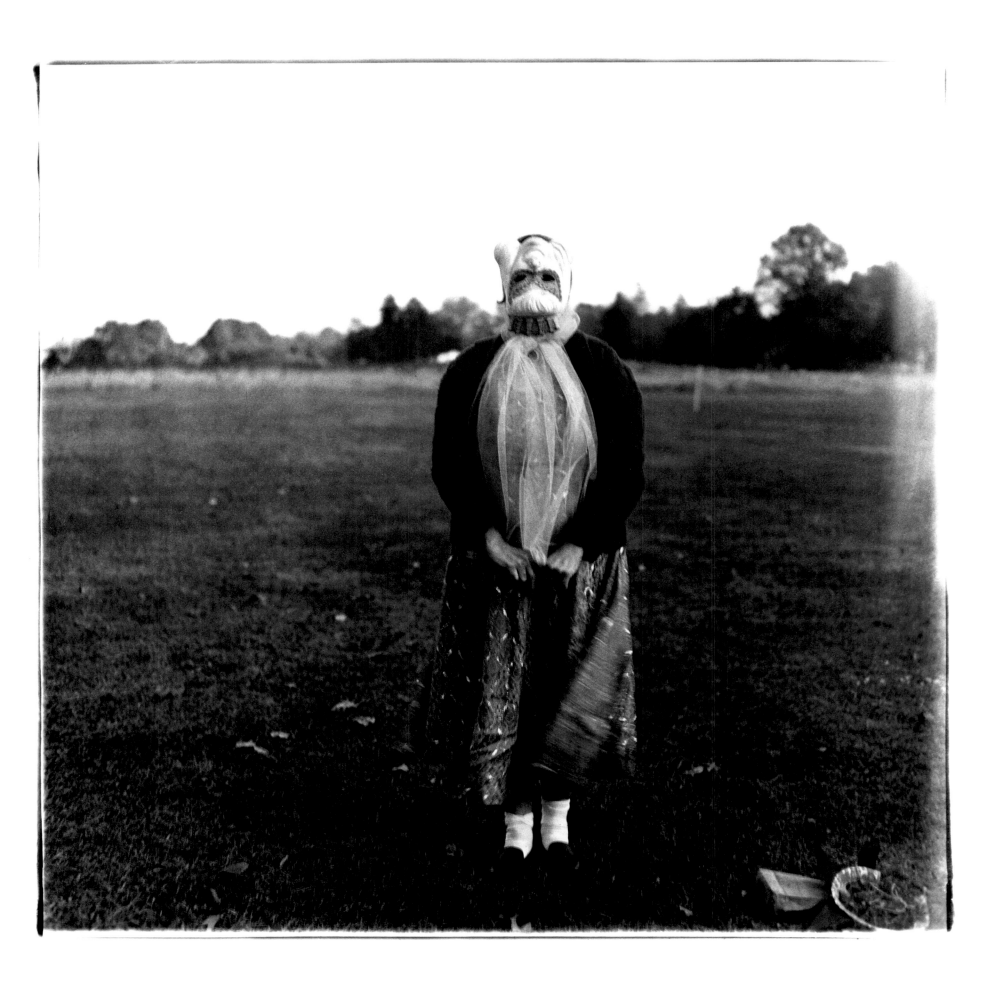

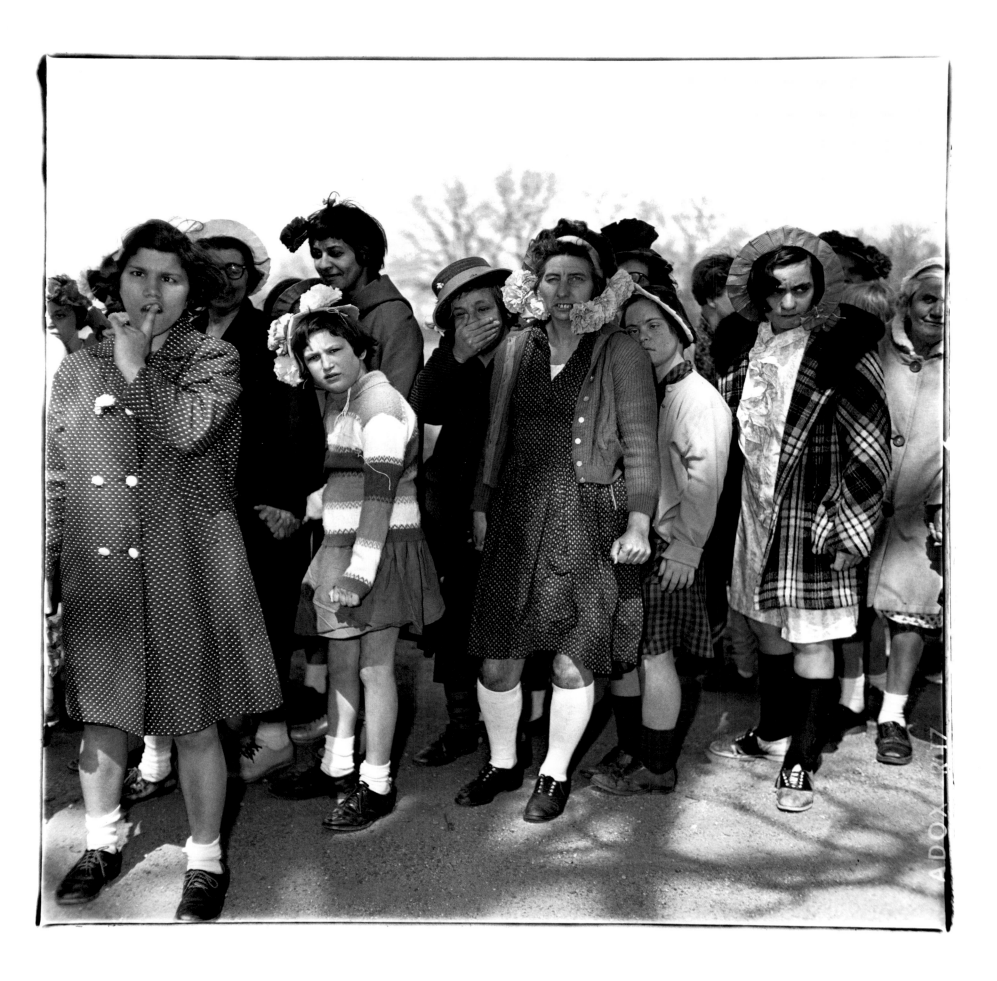

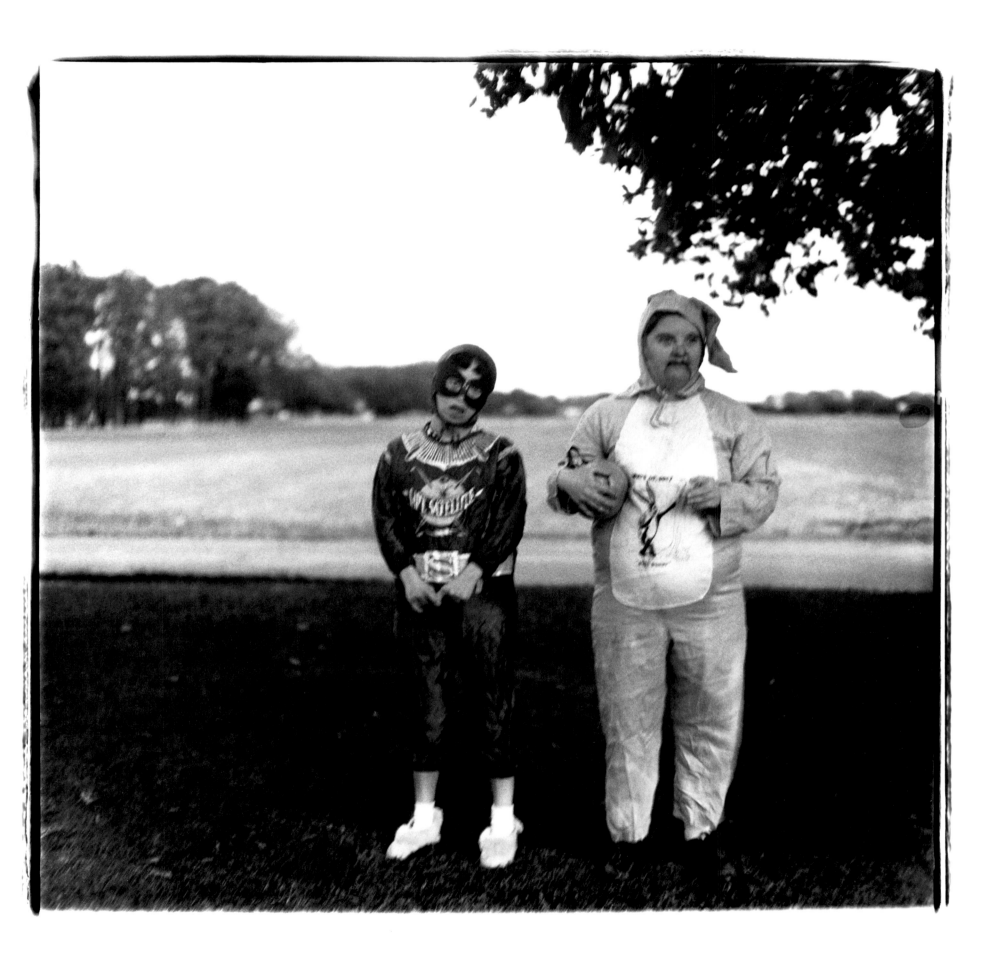

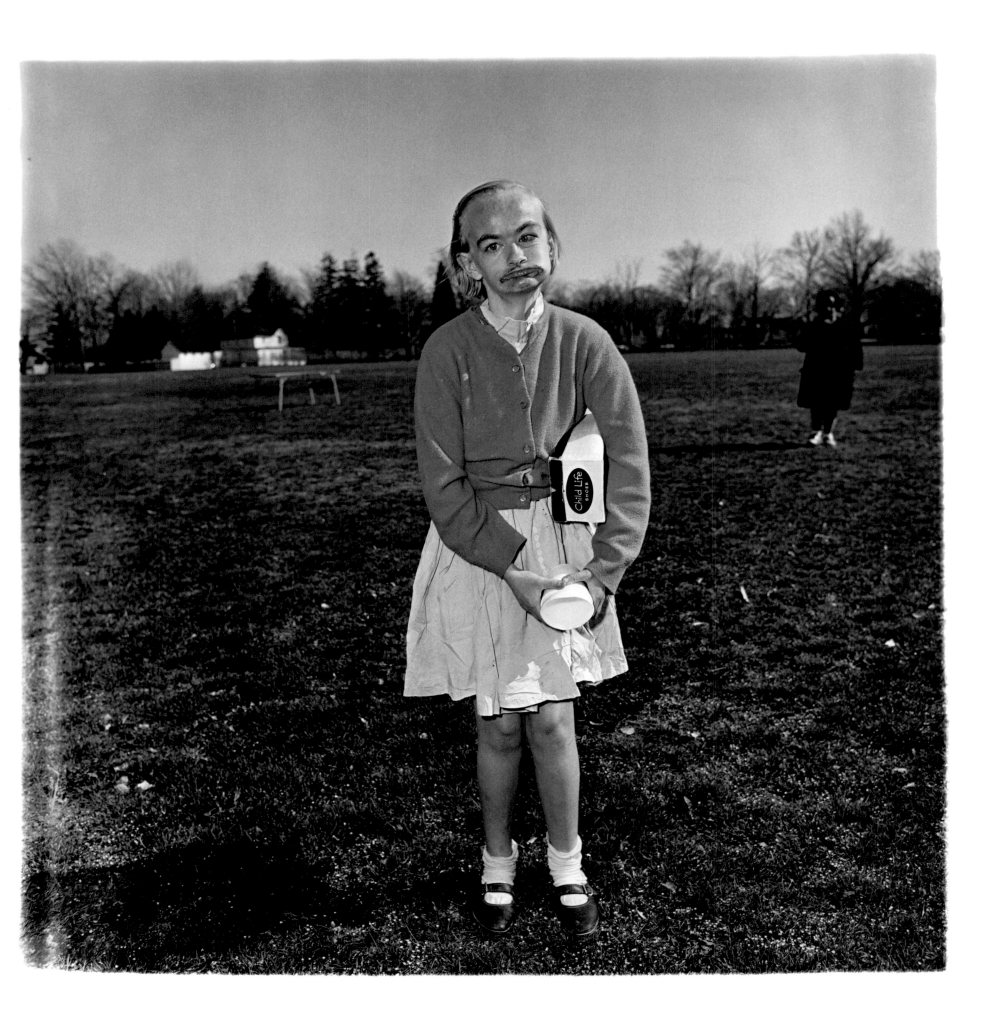

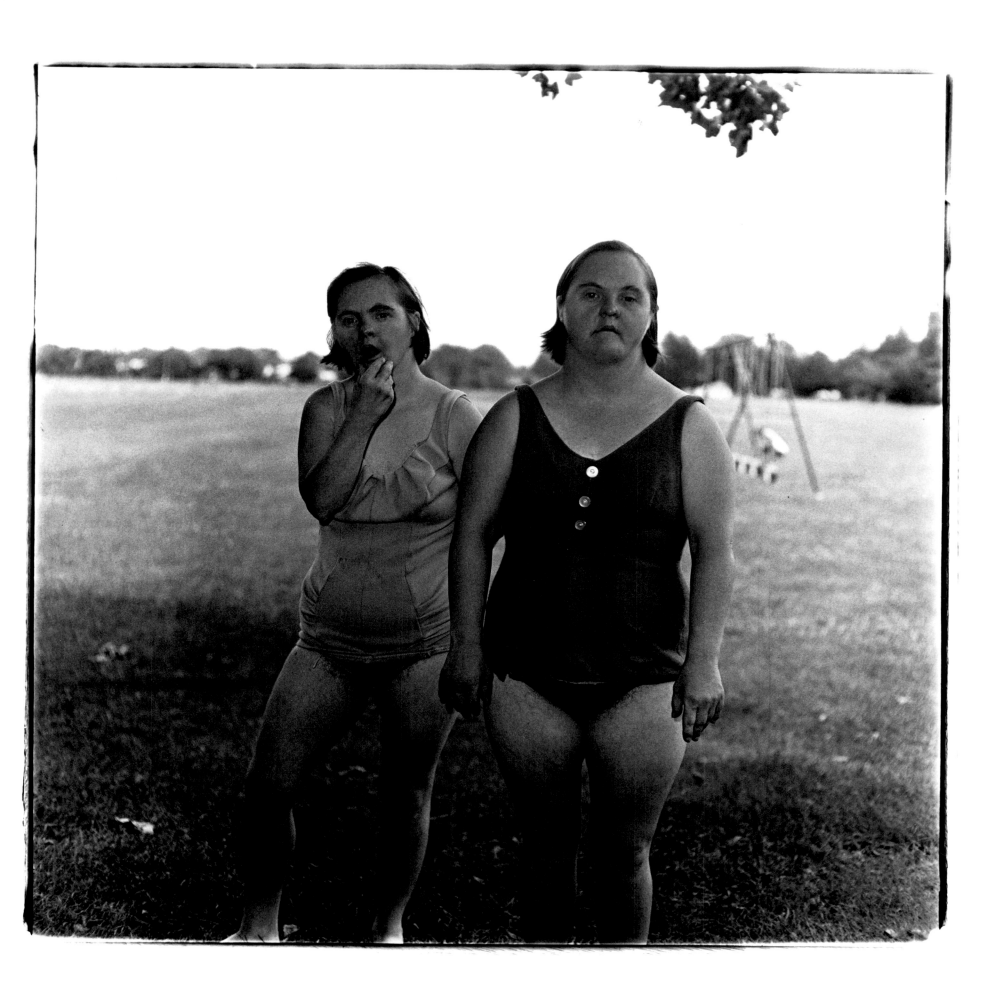

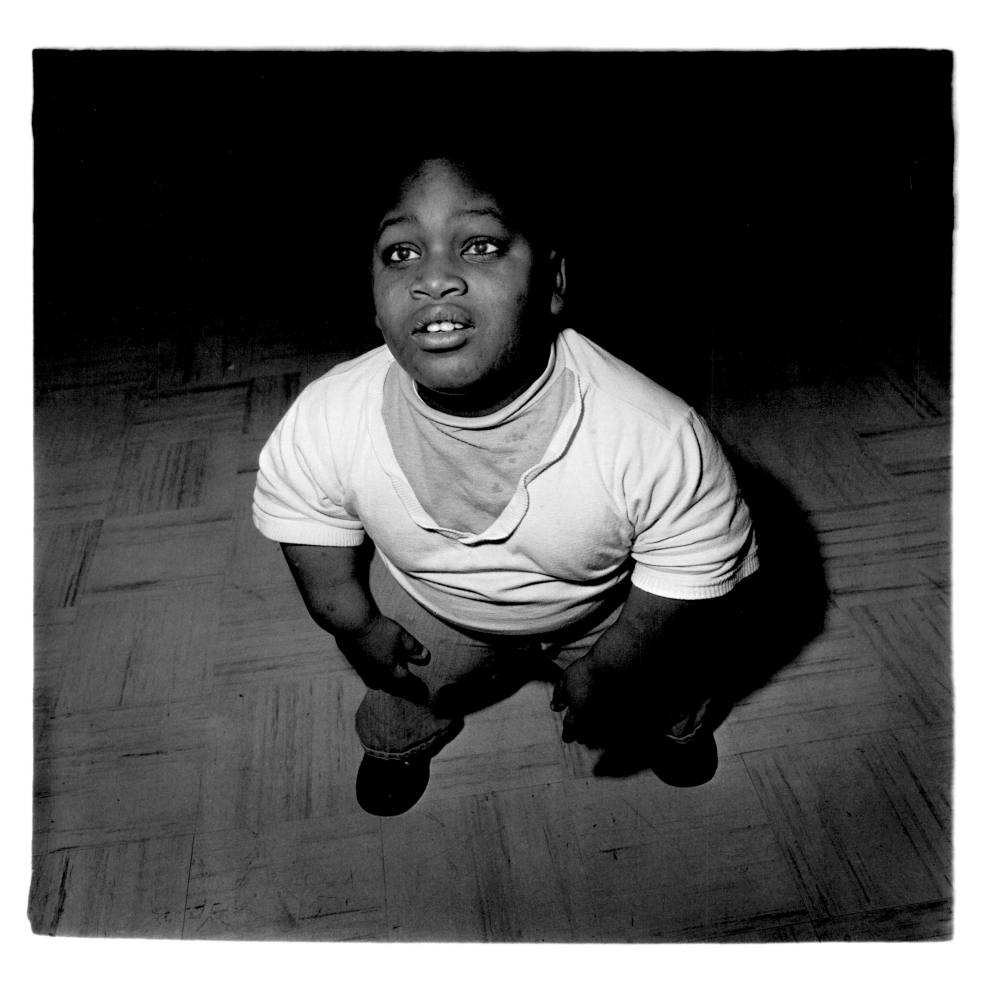

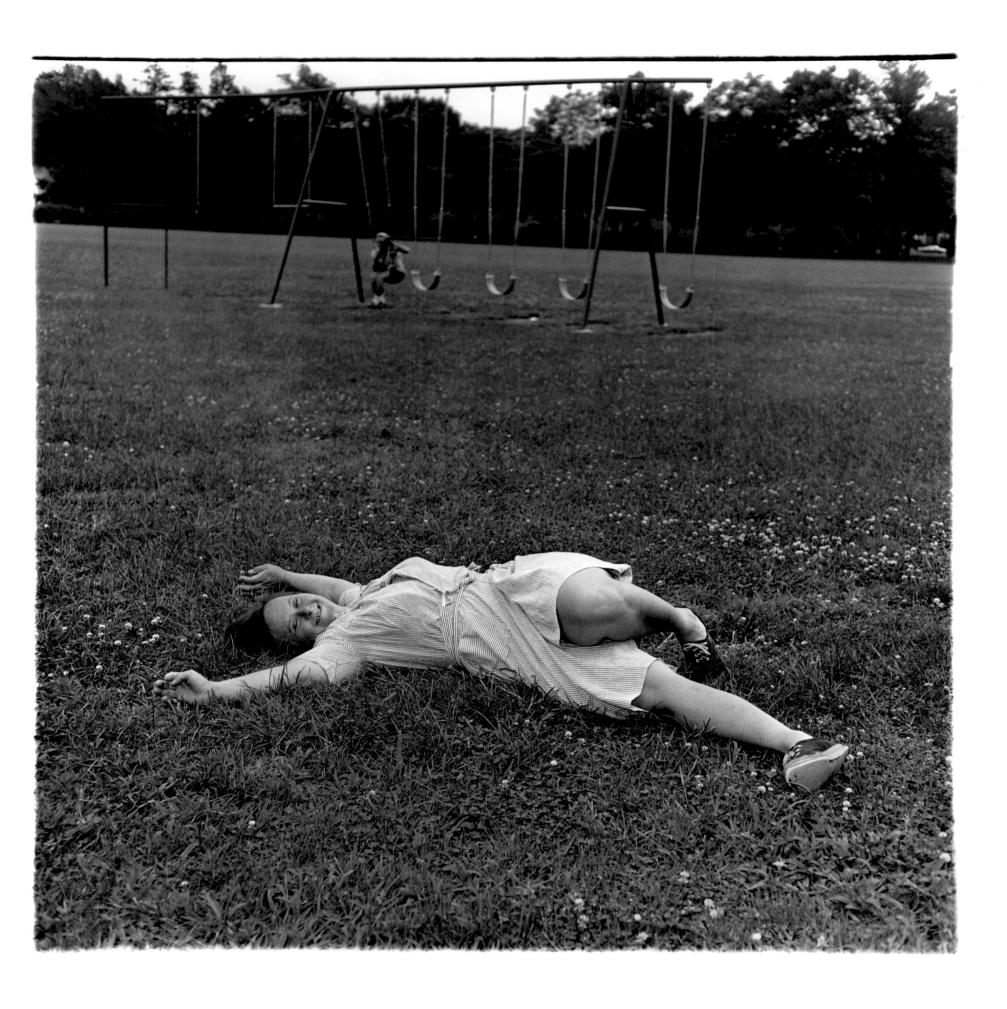

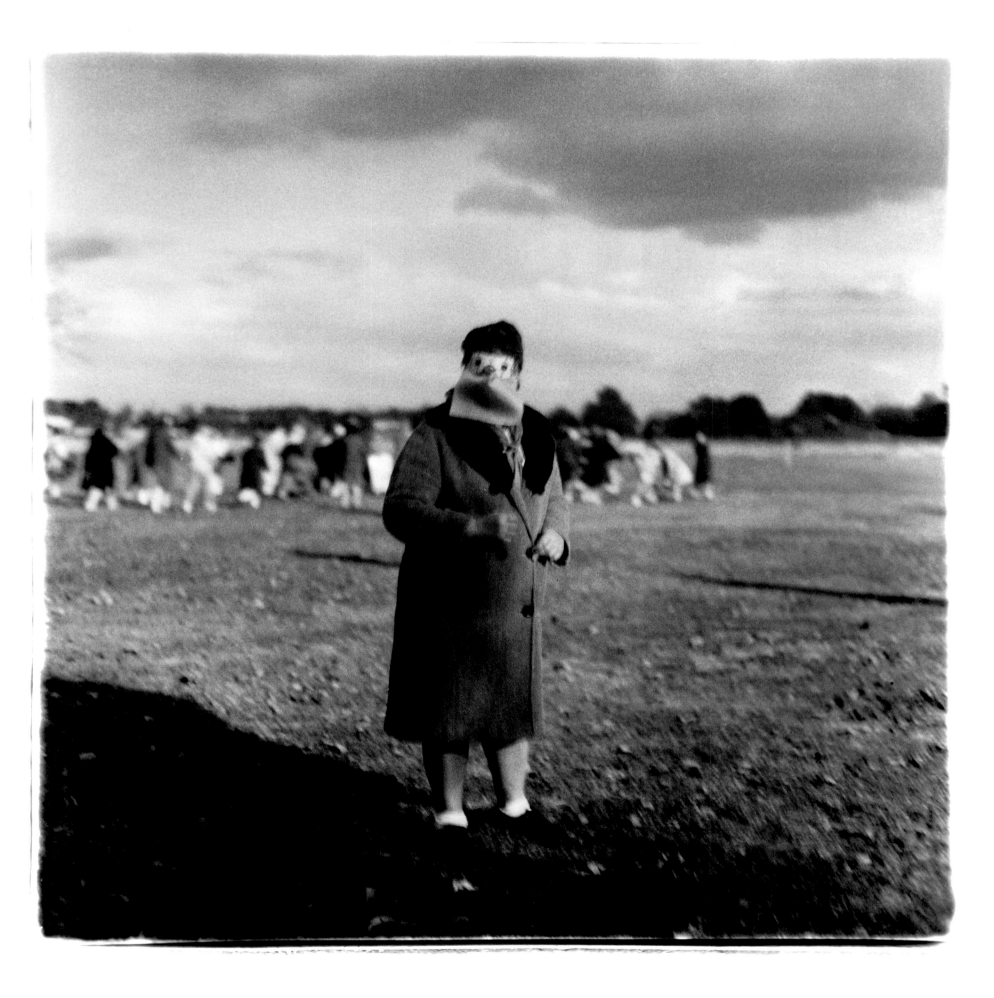

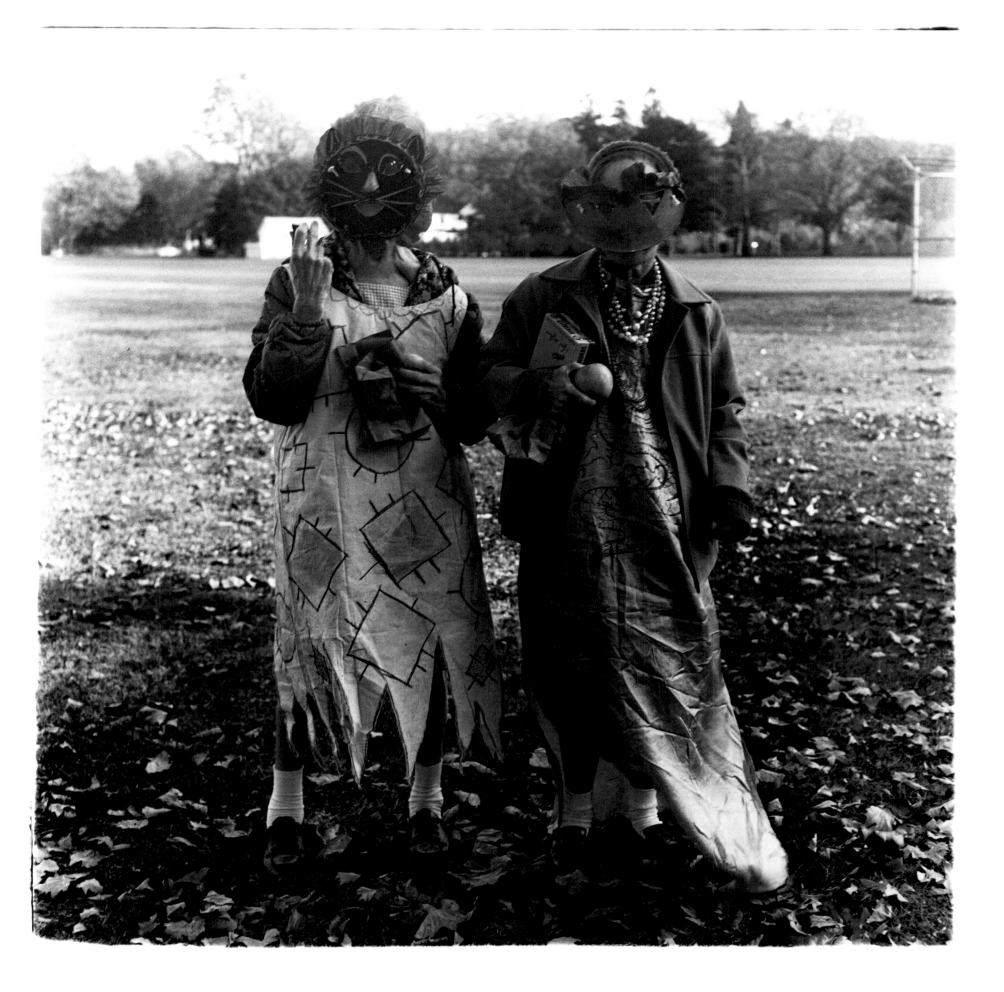

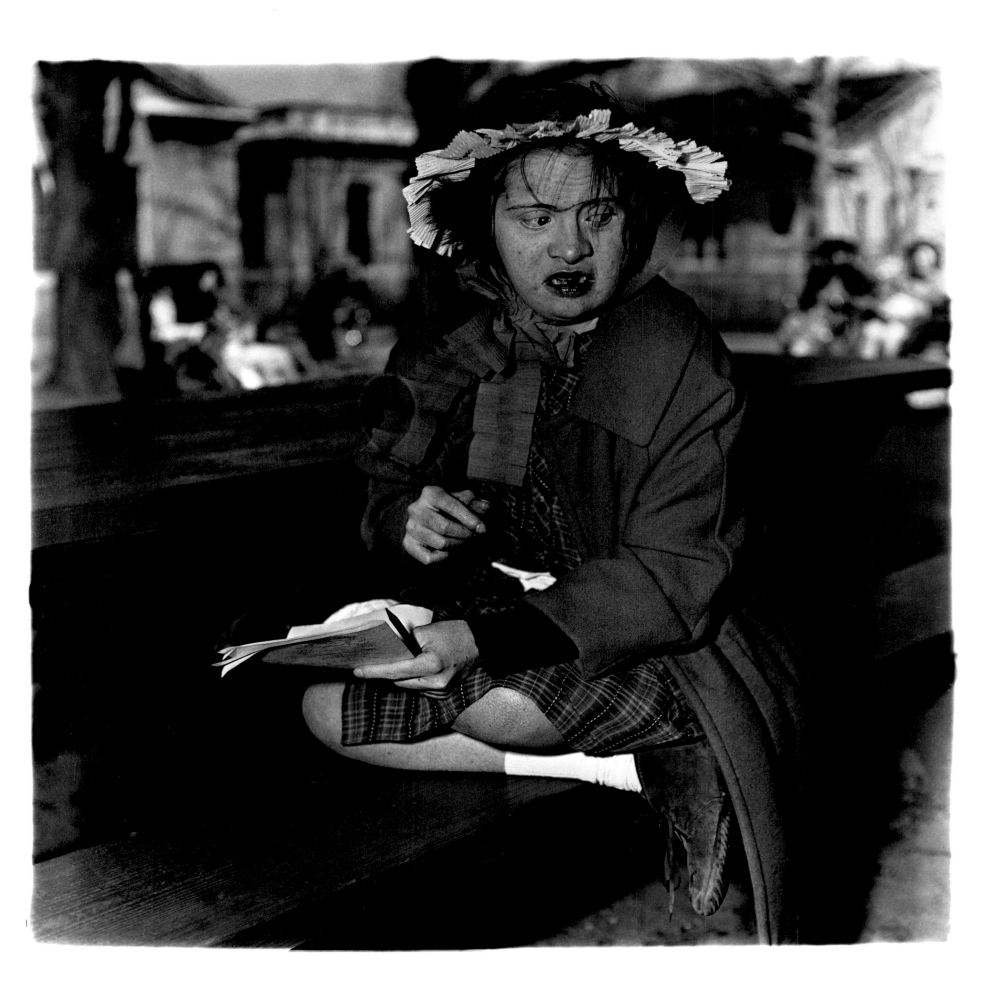

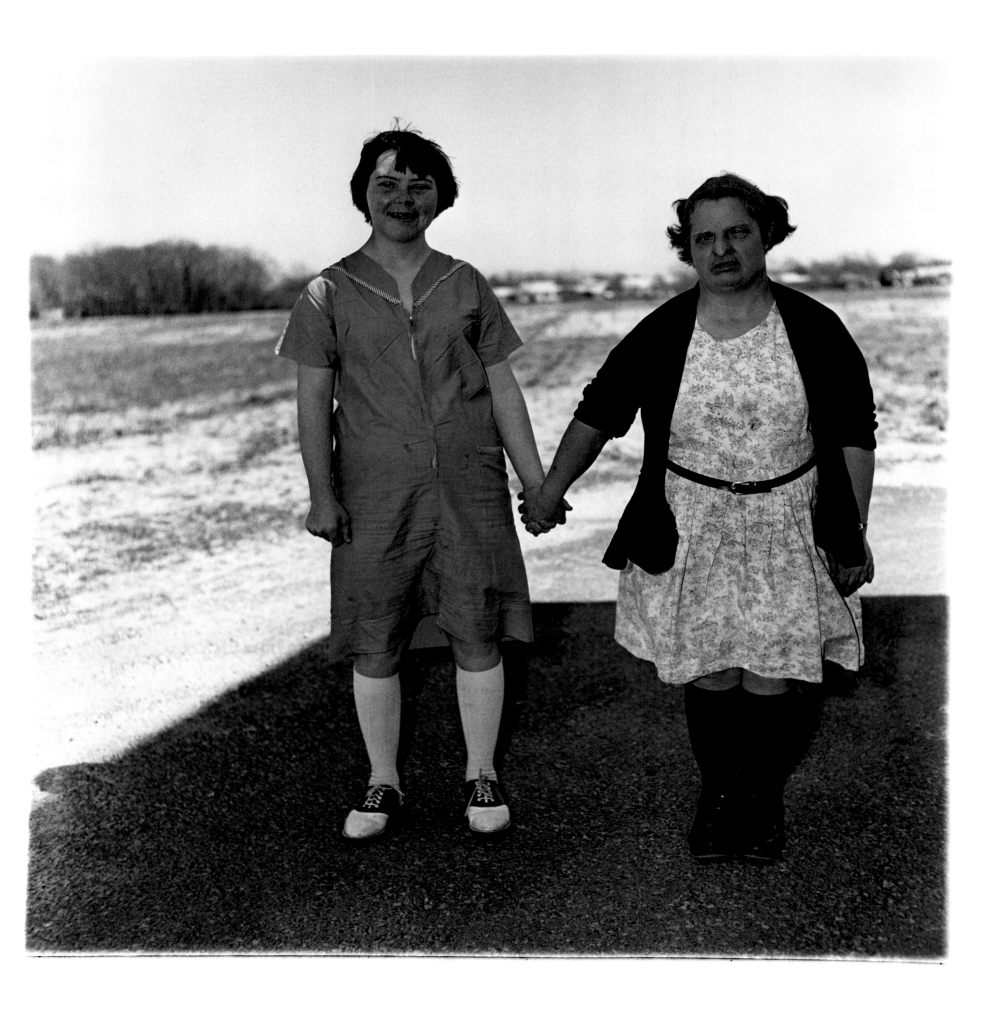

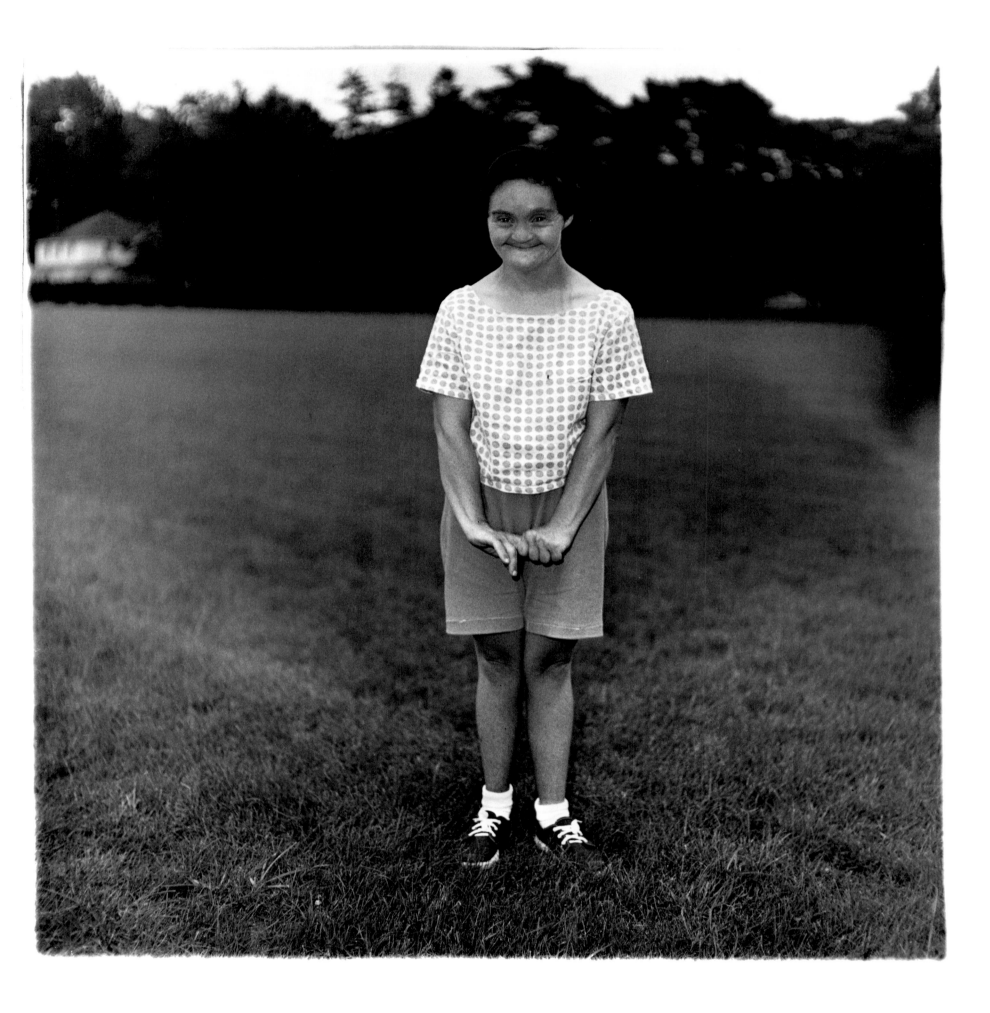

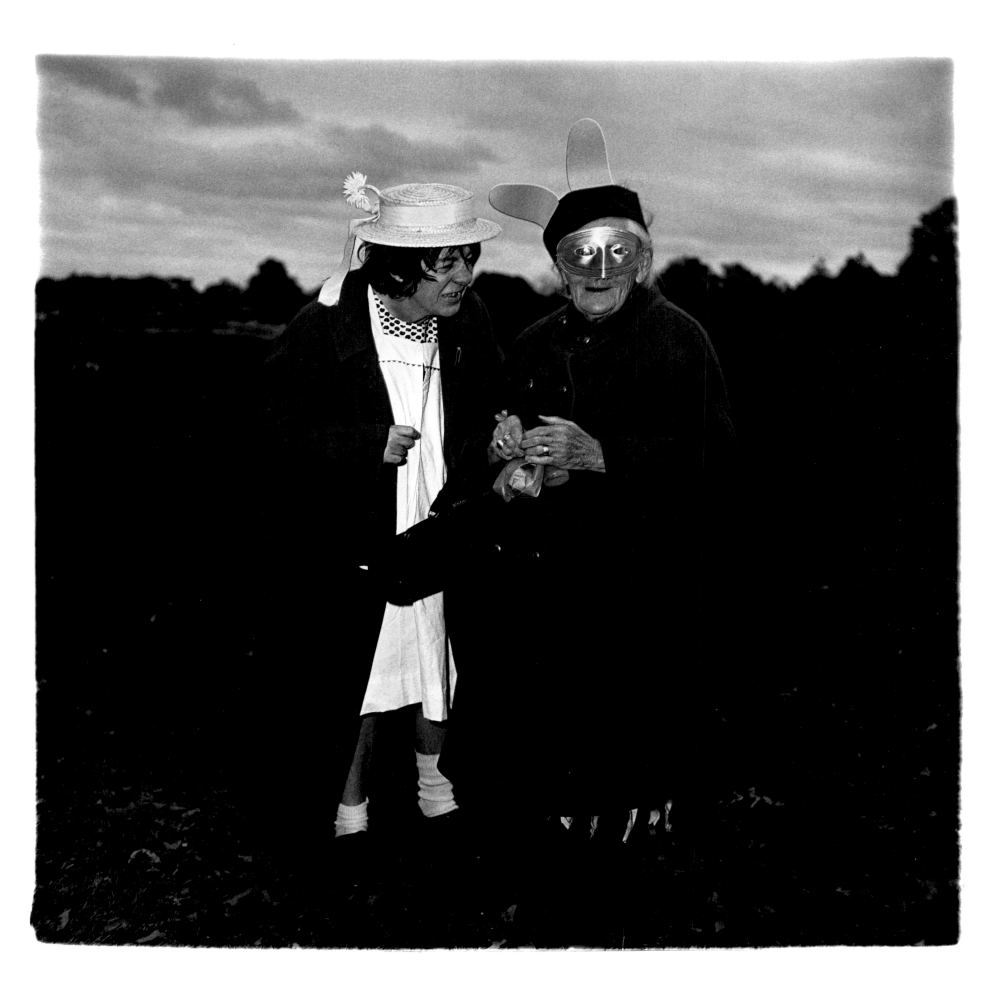

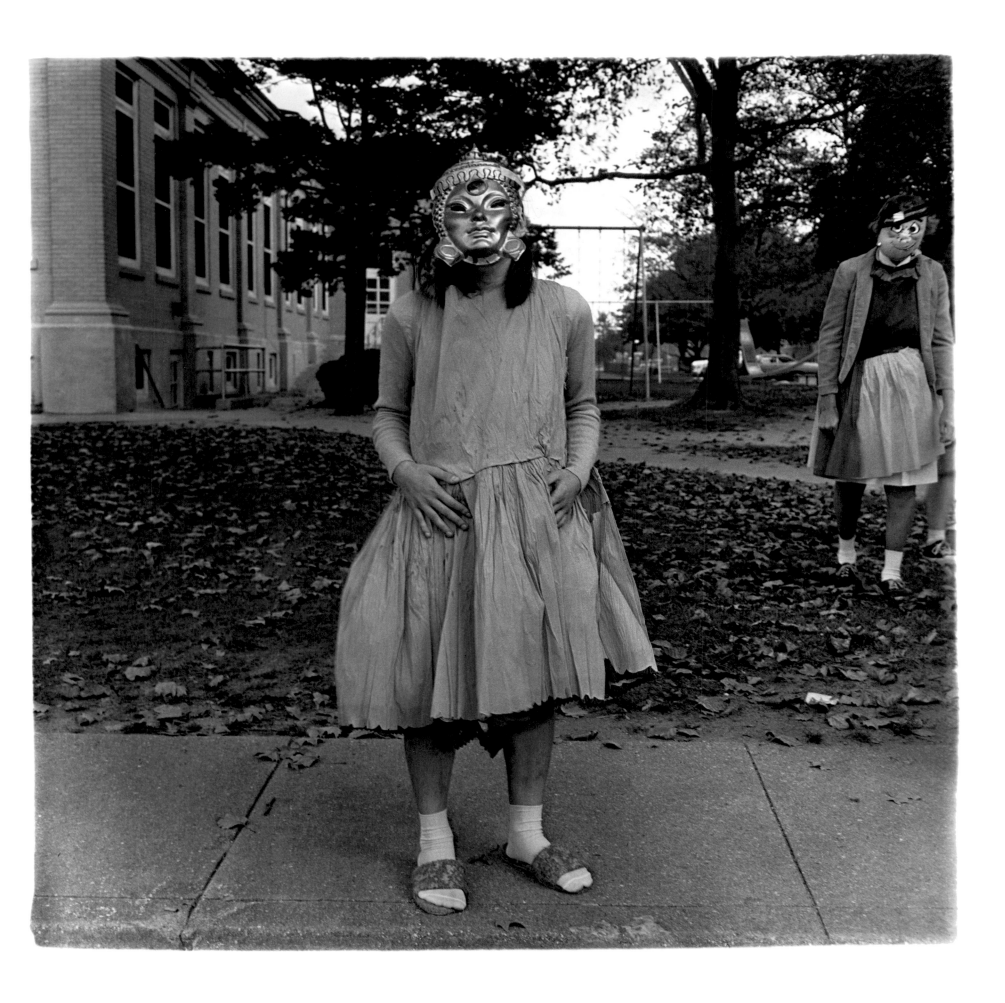

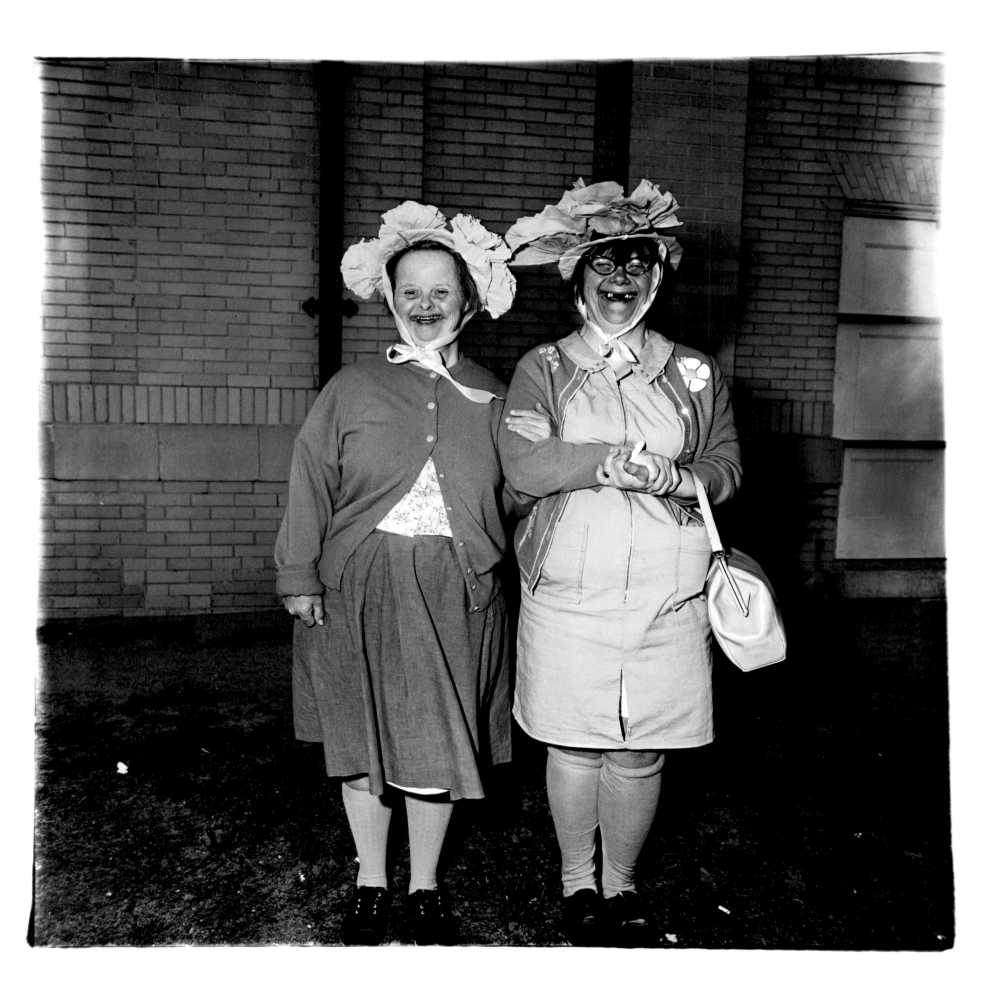

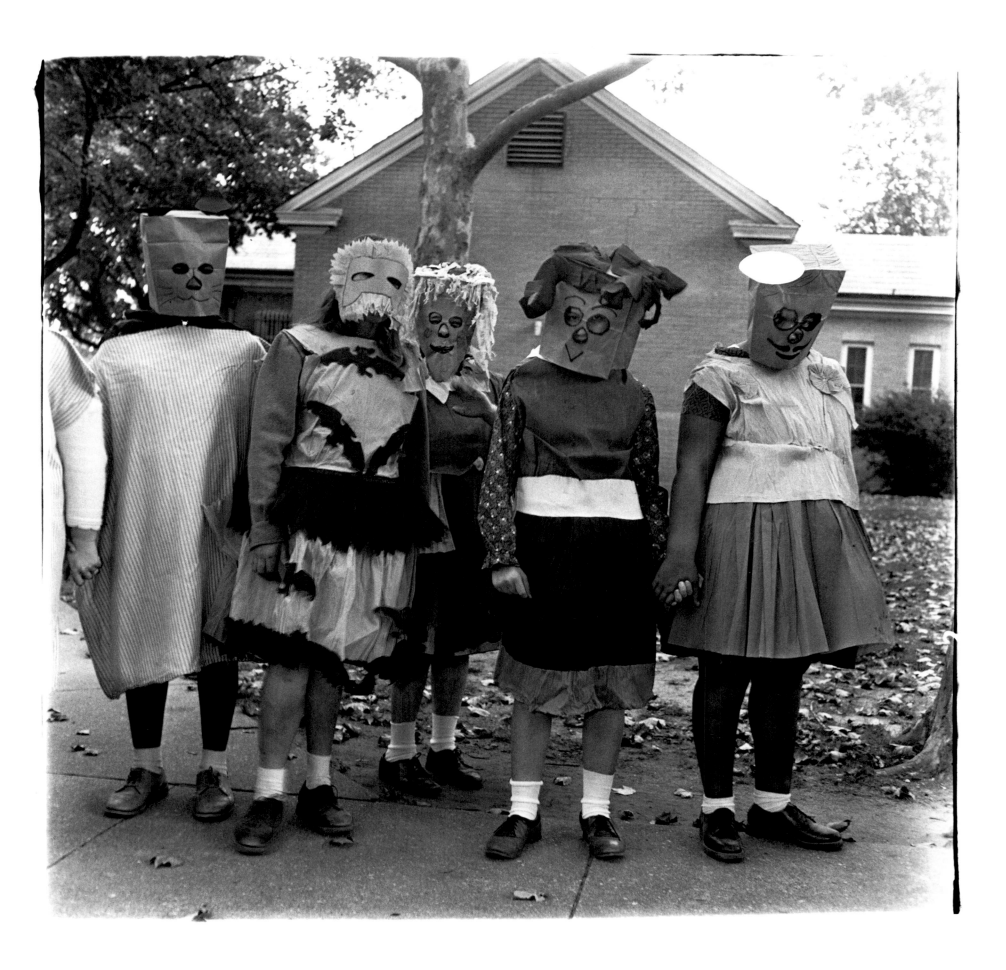

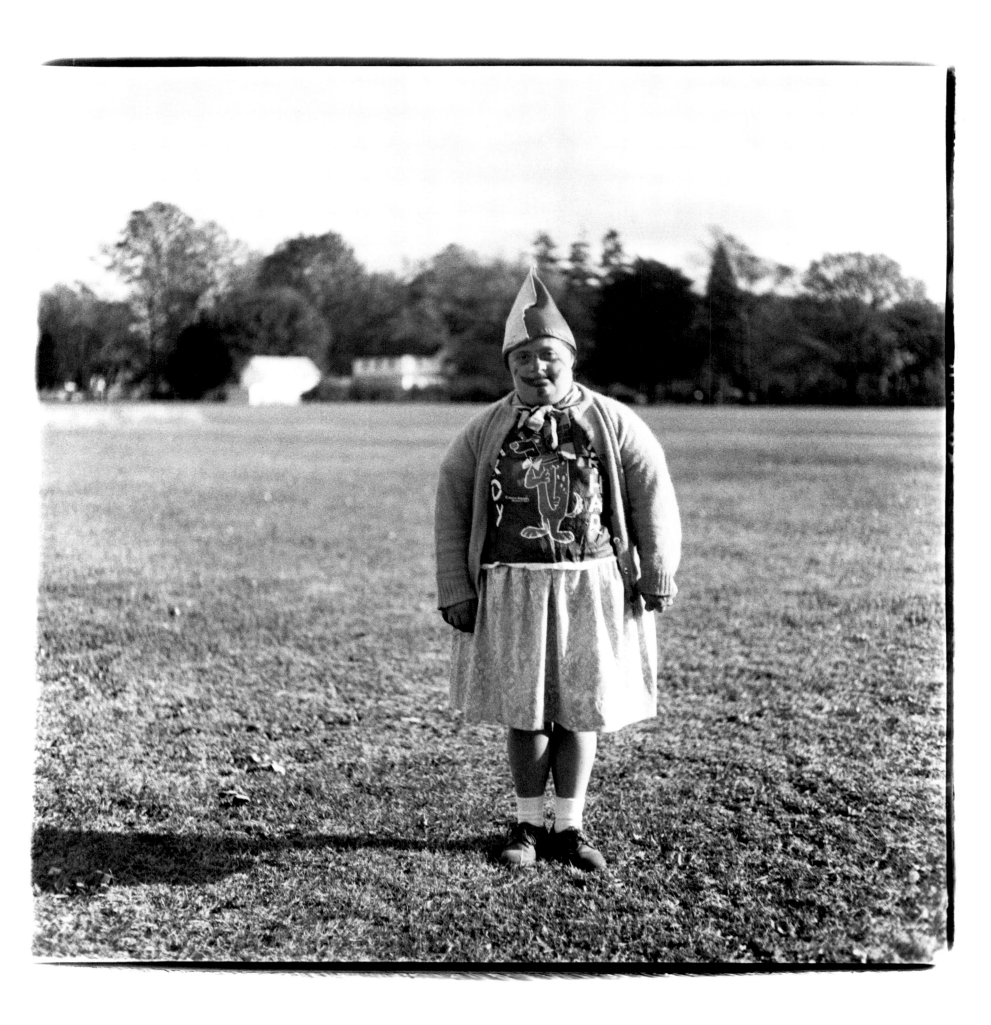

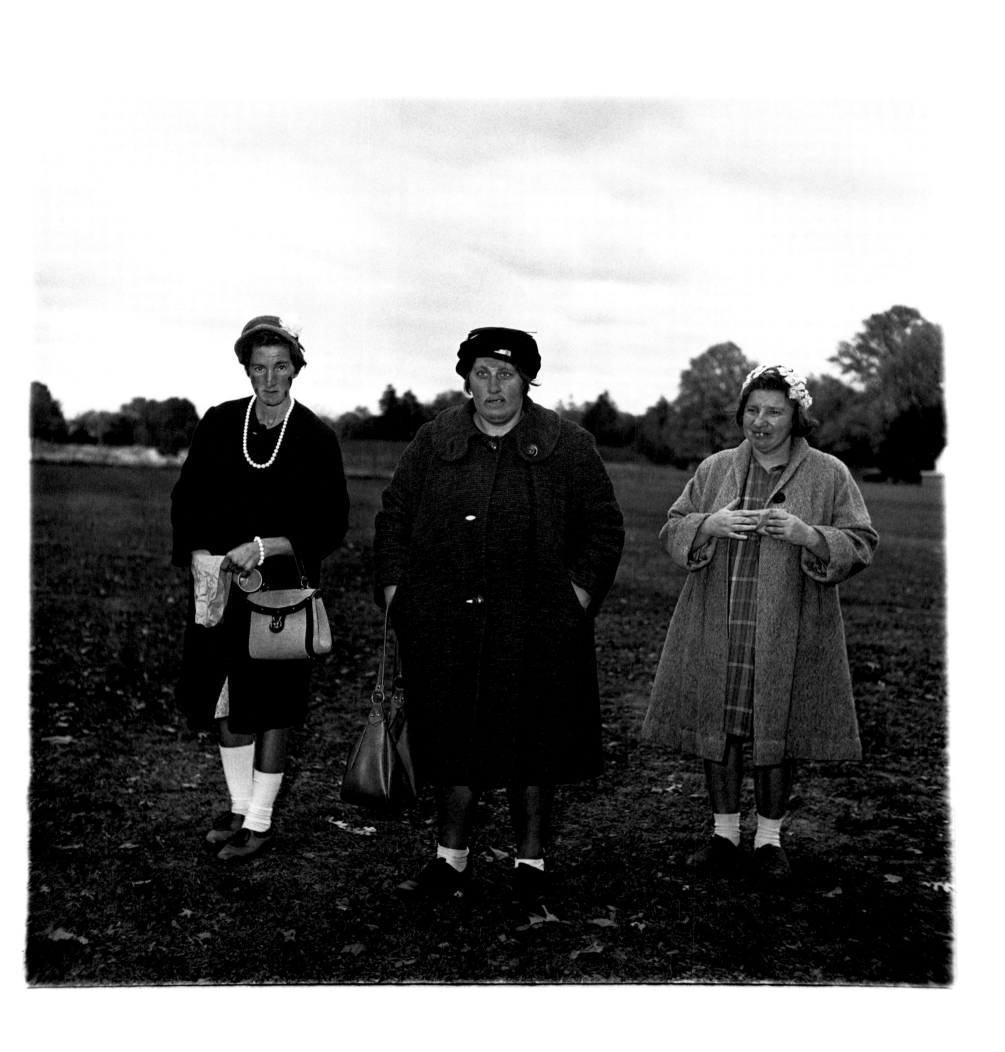

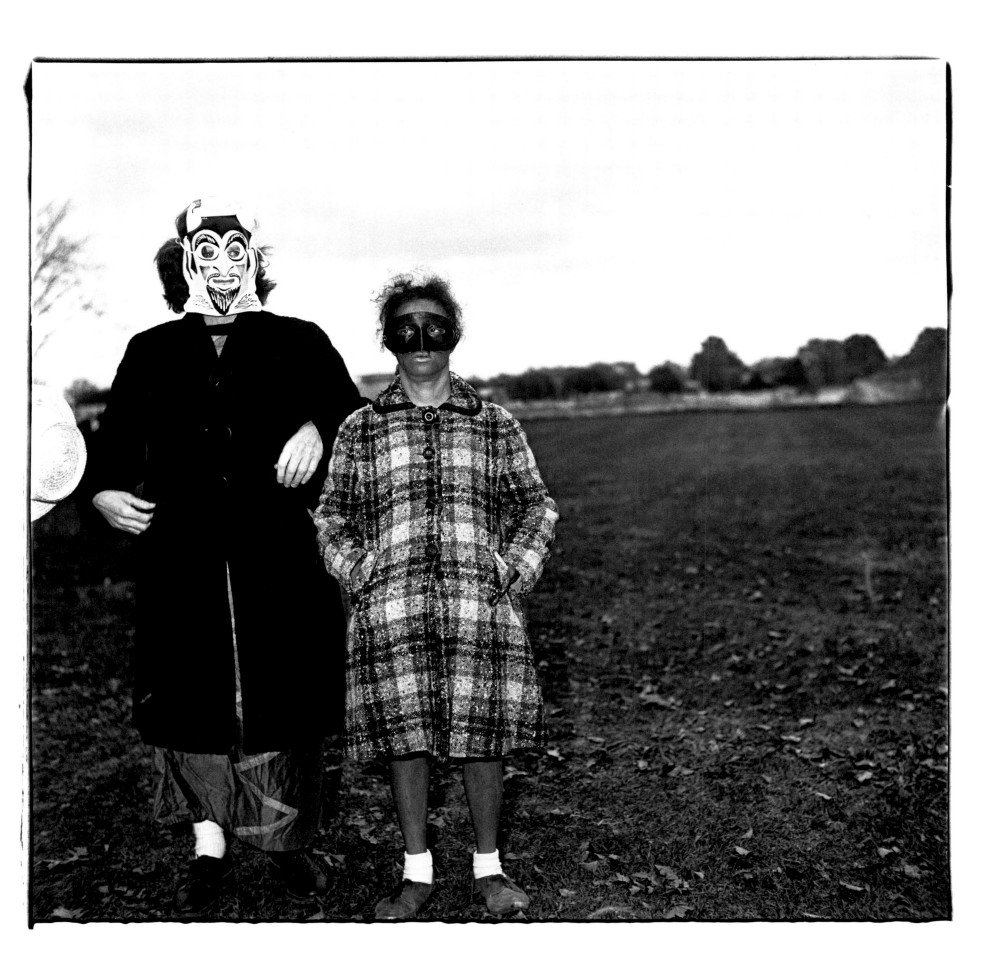

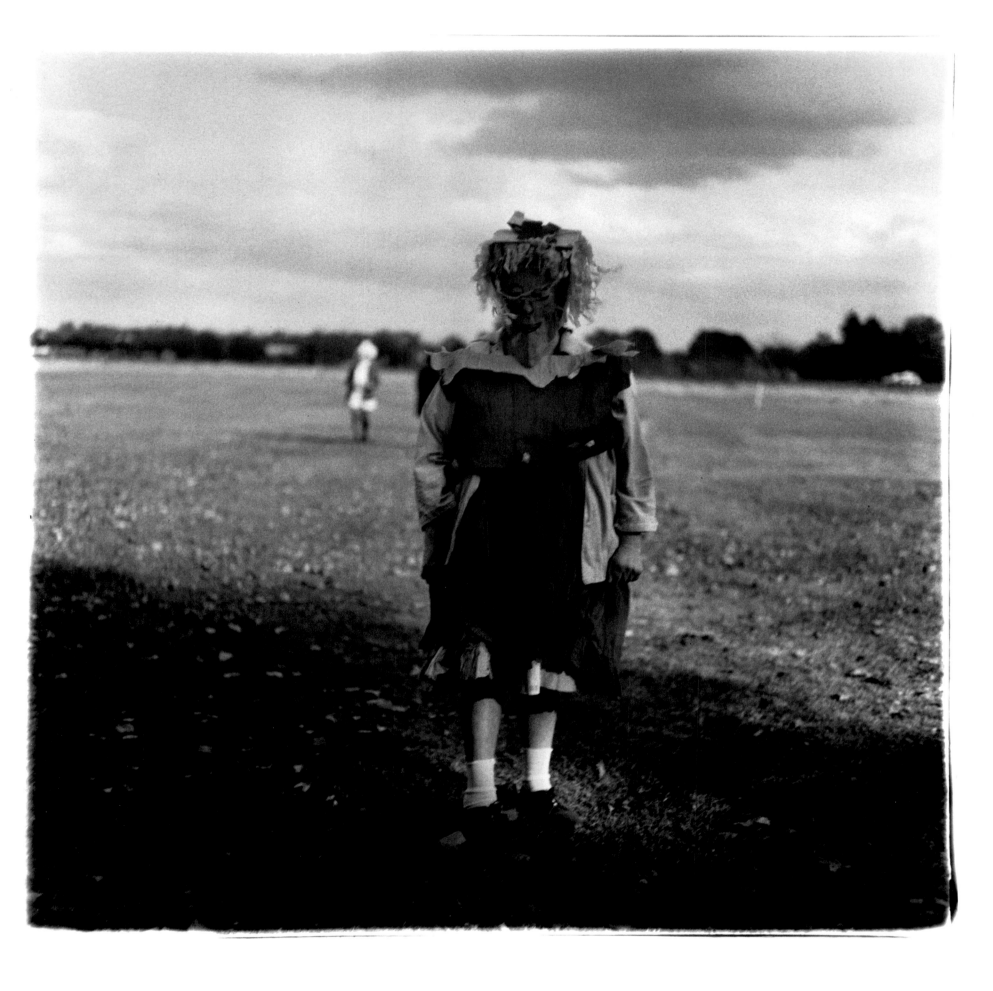

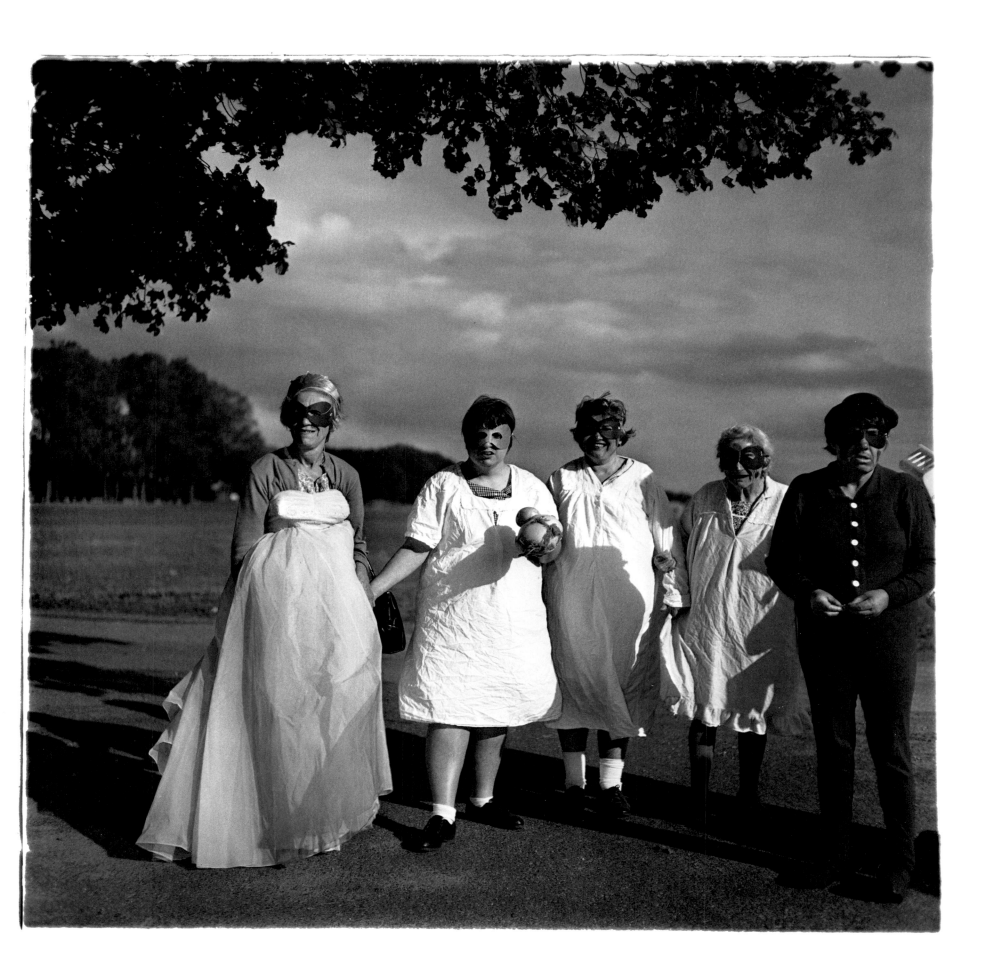

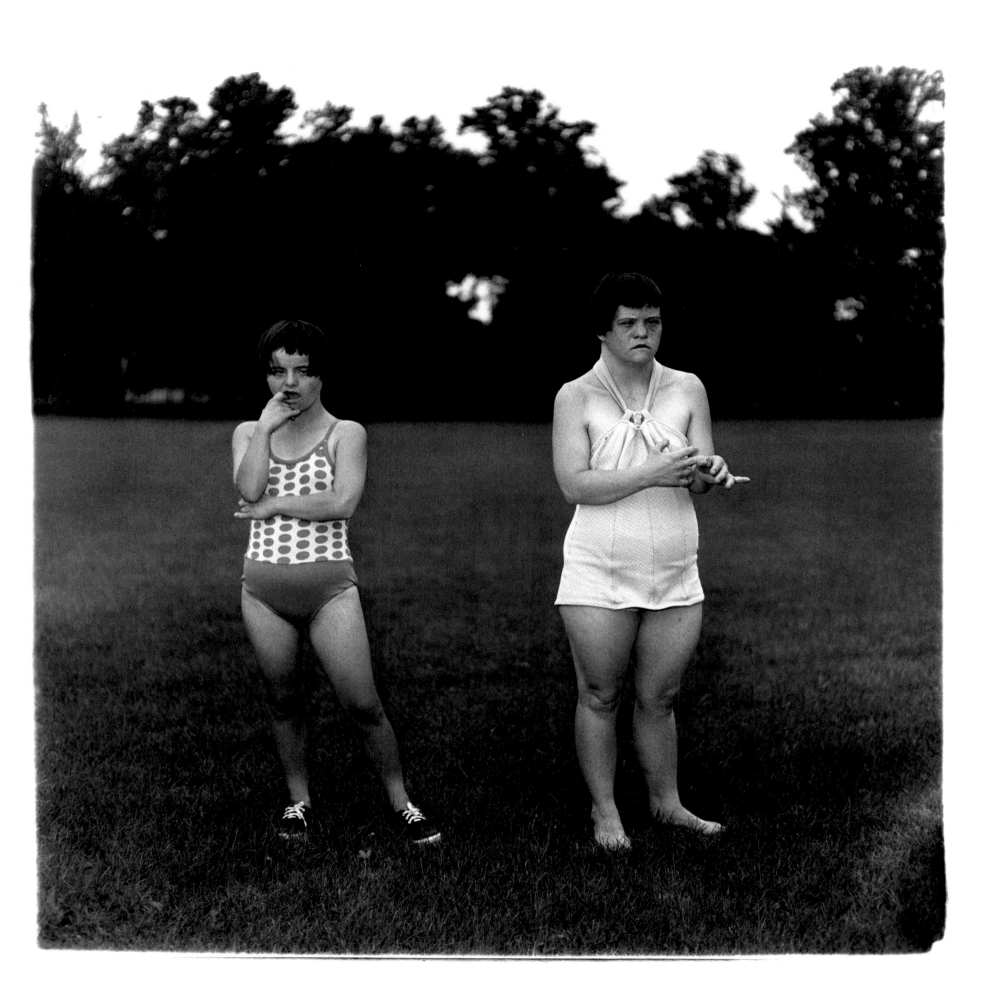

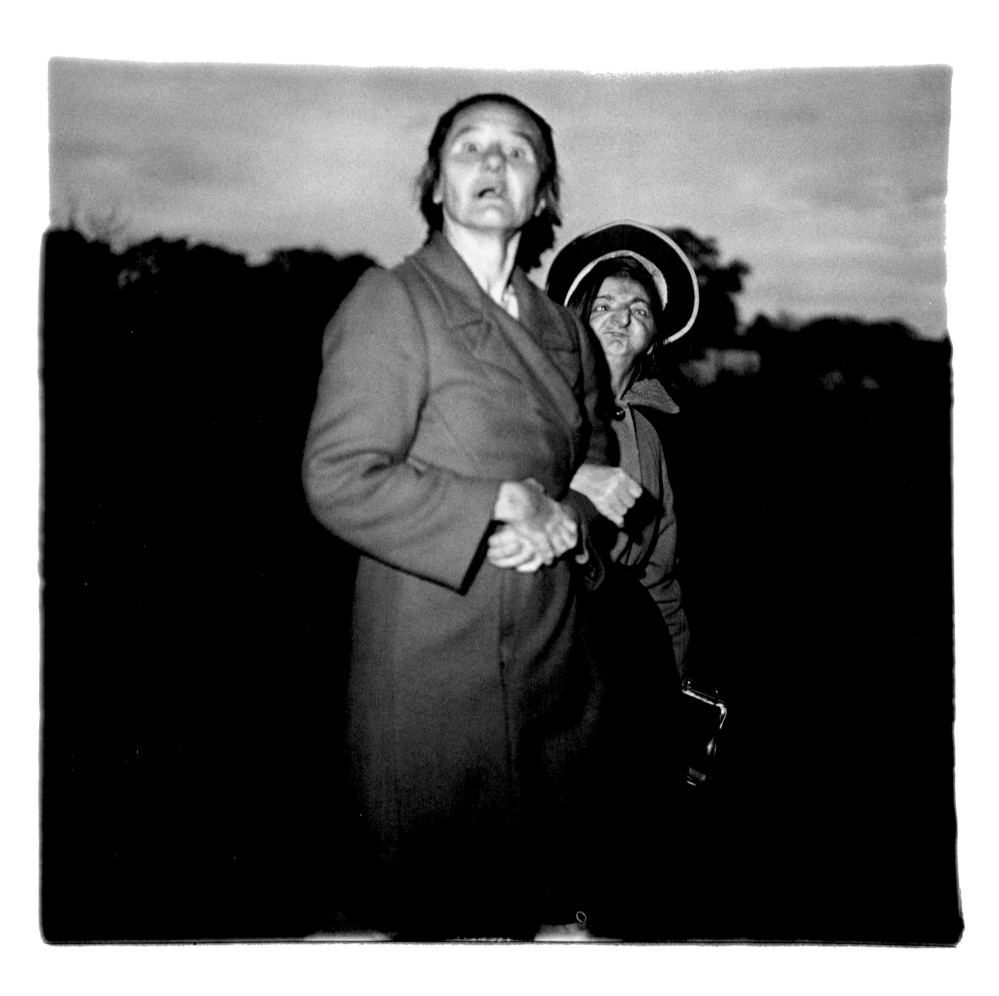

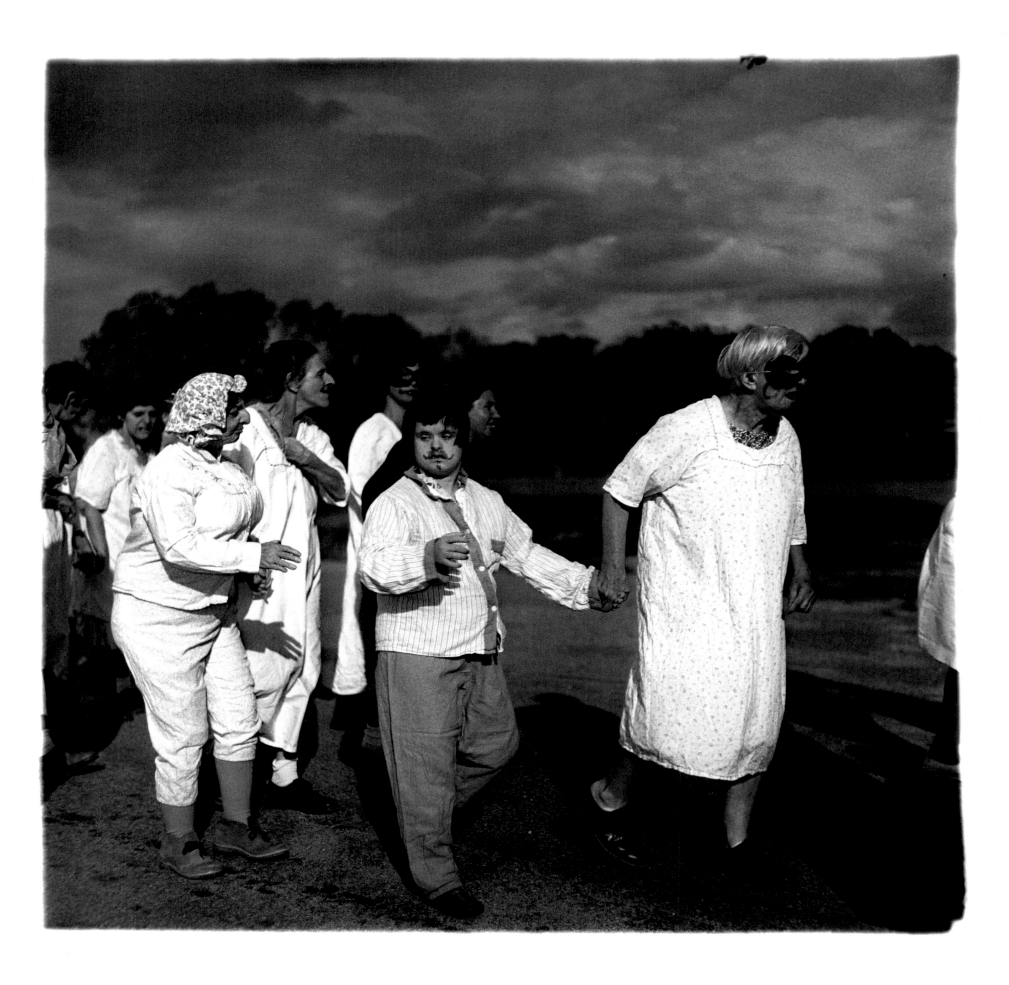

AFTERWORD

These photographs, most of which have never been seen before, belong to what has come to be known as Diane Arbus's UNTITLED series—by default, in a sense, since the individual titles she might have given them were never done. The photographs were taken at residences for the mentally retarded between 1969 and 1971, places she kept going back to every few months or so, to picnics, dances, on Halloween, in the last years of her life. This is simply information. What's in the pictures lies much closer to home.

When she made them, she had already staked out her territory as a photographer and there was no retreat. But, almost from the beginning, she recognized in these pictures something new, something she'd been searching for for a long time, uncertain what shape it might take. The discovery set her free. Although, as an artist, she was still on familiar ground, it must have felt for a while like a foreign country. The pursuit of what she'd seen in the pictures entailed giving up certain elements of a style and technique that had become identified with her work and, at least on the surface, seemed responsible for its unique character. She knew the value of what she was giving up and the value of what she was gaining in return.

Over and over again, throughout this body of work, she surrenders precision for lyricism, fixedness for movement, irony for a kind of emotional purity, authority for tenderness. She surrenders the power of the single, isolated image for the nonsequential narrative implicit in the many. Where her best-known work challenges us to look, or seduces us into looking, these photographs simply disclose themselves, as if content to be discovered. Her presence, once the invisible center of her pictures, the thing you couldn't see and couldn't ignore, is now subsumed within the image and goes all but unnoticed. The collaborator has become a witness.

This radical shift of style and technique didn't simply happen because she decided it was something she wanted to do. It occurred as a direct response to where she was, to the people she was with, the way they were with her, and to what she saw going on between them. No one else had ever posed for her so unself-consciously, with such abandon, such equanimity about their own sense of identity. Their abandon became hers. That's why none of her other photographs—including some of her most famous images taken during the same period—looks quite like these do. It wasn't a matter of technique invented for its own sake that could be imposed at will on any set of circumstances. Style, technique meant nothing to her unless it formed an indissoluble partnership with content.

She wasn't interested in making pictures that looked like art, or illustrated an opinion, or showed us things the way we wished they were. She wasn't interested in self-expression. There are beautiful photographs here and making beautiful photographs was important to her. But, for her, the beauty of the photograph originated in the thing itself. Whatever the image or the quality of the print achieved had to remain faithful to the facts. As she once said, "A photograph has to be of something and what it's of is always more remarkable than the photograph. And more complicated."

But if her allegiance to the facts and a respect for their integrity dictated her approach to making photographs, the results are paradoxical. They have none of the comforting dependability of a science. Her photographs are full of information, which nonetheless provides no names or addresses, no vital statistics, and seems to refuse to add up to reliable conclusions. They're full of details, but many of them are details we feel we've never seen before, composed of the stuff life keeps hidden in the seams between one second and the next.

In recording the facts and continually reminding us that facts lie at the root of what we're looking at, her photographs undermine our concept of reality and turn it on its head. Things we took for granted as mundane begin to make us marvel; dualities of the mind or of the spirit find their physical manifestations, while what we once believed to be the exclusive province of dreams turns out to exist right in our own neighborhood with its feet planted firmly on the ground. The world,

as portrayed in her photographs, appears a much stranger and more wondrous place than we ordinarily perceive it to be. It looks that way because over and over again she found it to be so, and in her hands, the camera, with its uncanny ability to expose the unseen, produced the proof.

That's what she meant when she said she believed there were things nobody would see unless she photographed them. She wasn't talking about subject matter. She wasn't saying that if it weren't for her photographs, nobody would have seen a giant, or women who were really men, or a ghost-like figure in a white sheet standing in a field at dusk. She meant something deeper than vicarious tourism. She wasn't talking about who or what she saw, but about the experience of seeing it and the power of her photographs to make that experience visible. It might be said, whether by way of praise or criticism, that this was a personal vision, and of course it is, but her photographs have no such modesty, take refuge in no such alibis. They state as calmly as only the deepest certainty can: This is how it is. In doing so, they act as an assault on all polite, habitual blindness to what's really there.

This can be disquieting, even shocking. Her photographs seem to catch us and to hold us in that state between sleep and waking, with all our labels for things in disarray and our identities askew. If we try to defend ourselves against their apparently indisputable rendering of the way things are—by dressing them up and burying them in words, by reading them as x rays of the soul, investing them with the power to lie or tell the truth, to be kind or cruel, moral or immoral—her photographs remain impassively silent. They have nothing to say about such things. In their silence, in their stillness, they begin to convince us that the act of looking—looking as remorselessly as only photographs enable us to do, as the best of them compel us to do—is the real original sin, the real source of forbidden knowledge. It brings us face to face with stuff we feel we weren't meant to know.

Forbidden or not, this was the territory Diane Arbus ventured into when she first realized she was becoming a photographer. The act of looking, as her respect for photography required her to practice it, was an investigation into the nature of things. As such, it entailed power and responsibility and a faith in the lucidity of appearances as the signs and symptoms of reality. Making

photographs meant approaching the unseen by means of a disciplined attention to the evidence in the hope of eliciting a few of its best-kept secrets. It was her vocation, and she pursued it in that spirit: with daring, tenacity, and a willingness to abandon a lot of baggage at the door. Whatever making photographs demanded of her, looking at her photographs demands, to a small degree, of us. By meeting them halfway, we risk enlarging our capacity for wonder, recognizing things we forgot we knew, and sharpening our ability to decipher what the world has to show us about itself.

In her UNTITLED series, with its unique concentration on aspects of a single subject that seemed, at least for a time, inexhaustible, Diane Arbus may have found her most transcendent and consistently romantic vision. These images—created out of the courage to see things as they are, the grace to permit them simply to be, and a deceptive simplicity that permits itself neither fancy nor artifice—show us metaphors embodied in the facts, riddles without words or answers, fragments of an unwritten fairy tale. They are revelatory rather than didactic, but their very existence seems proof that nothing conjured by the imagination could be as awesome or exhilarating or magical or baffling as an encounter with reality. The photographs appear to be documents of a world we've never seen or imagined before—one with its own rituals and icons, its own games and fashions and codes of conduct—which, for all its strangeness, is at the same time hauntingly familiar and, in the end, no more or less unfathomable than our own.

DOON ARBUS

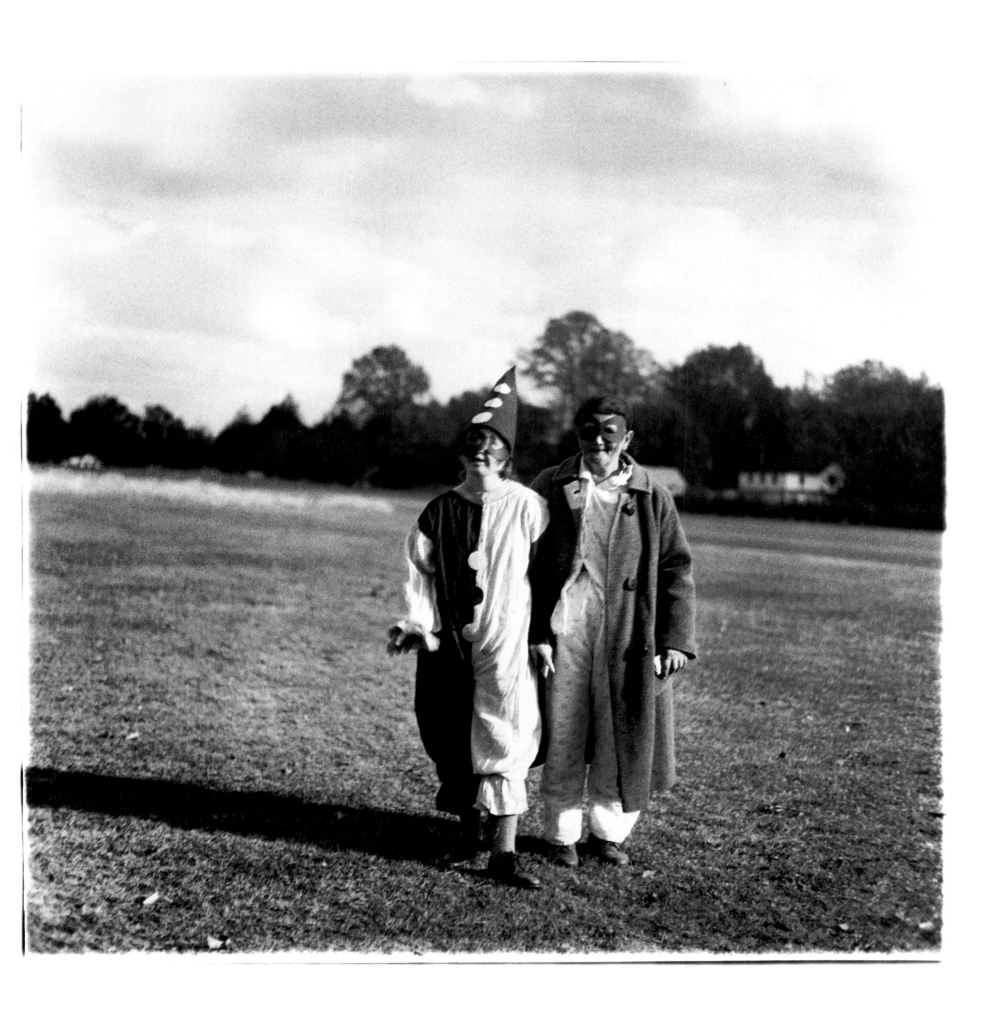

ACKNOWLEDGMENTS

Photographic prints by
NEIL SELKIRK

Prints courtesy of
THE ROBERT MILLER GALLERY

Duotone separations by
ROBERT HENNESSEY

Design assistant
FRANCESCA RICHER

Typesetting and composition
TERENCE WIGHT

Printed and bound by
L.E.G.O. / EUROGRAFICA
Vicenza, Italy

Published by
APERTURE
20 East 23rd Street, New York, New York 10010

MICHAEL E. HOFFMAN Executive Director
MICHAEL SAND Managing Editor
STEVAN A. BARON Production Director
SANDRA GREVE Production Manager

THIS BOOK WAS EDITED AND DESIGNED BY DOON ARBUS AND YOLANDA CUOMO

THIS BOOK WOULD NOT BE WITHOUT MARVIN ISRAEL

It was made with the help of
AMY ARBUS RICHARD AVEDON THERESA CAMPBELL
MARY DRUGAN BURTON JOSEPH ELIZABETH PAUL SUSAN SELKIRK
NORMA STEVENS ROGER STRAUS III